I R E L A N D I N O L D

C000132850

TRIM

ANNE CRINION
& JAKE CRINION

The
History
Press
Ireland

First published 2016

The History Press Ireland
50 City Quay
Dublin 2
Ireland
www.thehistorypress.ie

The History Press Ireland are a member of Publishing Ireland,
the Irish Book Publisher's Association.

British Library Cataloguing in Publication Data.
A catalogue record for this book is available from the British Library.

ISBN 978 1 84588 166 5

Typesetting and origination by The History Press
Printed in Malta, by Melita Press

CONTENTS

FOREWORD

There is something about photographs from a bygone era that continues to fascinate people of all ages. The desire to be transported back in time to rose-tinted, halcyon days gone by, if only for a few minutes, seems to get stronger the older we get.

Nostalgia clings to photographs like household dust. I well remember recently seeing a photograph from the era of my childhood of a street in Navan, where I grew up, which instantly brought long-buried memories tumbling back. Old shop fronts I could once again remember, long since gone, and names over business premises I had completely forgotten ushered in memories of some of the people and characters who once served customers within their walls and who themselves were part of the very fabric of local society at that time.

An American newspaper editor, Arthur Brisbane, coined the phrase 'a picture is worth a thousand words' and it's a maxim that newspaper editors the world over live and die by. It's a simple notion that applies especially to historical photography. Sometimes one simple picture can tell you more about history than the 1,500-word article that accompanies it.

Once taken to simply document the present, these images now act as a witness to the past.

The fascinating collection of historical photos put together by Anne and Jake Crinion in these pages encapsulates the essence of eras that have come and gone in Trim. These images speak their own stories, each one a snapshot of a long ago existence of people and places, which will be remembered by many to this day.

Many of the images have been taken by Anne herself; she has been witness over several decades to many of the events that have shaped the Trim we know today. From local landmarks and people to the ordinary daily routines of the past, they portray years of yore in a way that we can both empathise with and understand.

For many years between 1962 up to the 1990s, Anne Crinion was a regular photographic contributor to the *Meath Chronicle*, both documenting the news events of the day and supplying wedding photos. This is not her first book of photography. In 2012, she produced a book of local photographs to mark her 70th birthday entitled *50 Years Through the Eye of the Camera*, which was launched to considerable acclaim.

Her eye for capturing a frozen fragment of time has not diminished over the years and she was greatly aided in this project by her grandson, Jake Crinion, who recently graduated in film studies.

There is no doubt that putting together this book was a labour of love for a gifted photographer like Anne. Equally, I have no doubt that the memories it will evoke, happy and sad, good or bad, will transport readers back to a time when life was simpler and certainly less frenetic.

Ken Davis, Editor, Meath Chronicle, *1995-2016*

ACKNOWLEDGEMENTS

The people of Trim never fail to show their support and kindness, and this was very much evident when it came to compiling this book. A special thanks to Kathy Crinion for her insight and assistance. We would like to express our gratitude to the following for their help and contribution to this book:

Maria Kiely-Green, Jack Reynolds, Mike Kelly, Sisters of Mercy, Anne Sweeny, Barbara Flood, Una Ennis, June Smith, Anne & Mary Canty, Ann Murtagh, Peter Crinion, Betty Murray, Anthony & Lily Conlon, Johnny McEvoy, Lisa Rispin, Marian Durkan, Matt Gilsenan, Eugene Kiely, Liam Anderson, Mary Rigney, Fr Sean Henry, Geraldine Gilsenan, Caroline Markey, Linda O'Brien, Annmarie Cully, Linda White, Noel E. French, Stephen Leonard, Frank Lynch, Phil Cantwell, Judi Carroll and Kit O'Donnell.

ABOUT THE AUTHORS

The authors Anne and Jake Crinion are grandmother and grandson, two different generations with the same love and passion for their hometown of Trim. Anne started her photography career in the early 1960s with a camera (a Ricohflex) purchased for her by her bother Matt; she started with wedding photography and very soon she was developing and printing from her own darkroom. Her work was much sought after by local media and press and many of her photographs are used in this book. Anne is also a fine artist and two of her paintings were purchased for the Government Collection.

Anne's son Peter, who now resides in Australia, inherited his mother's love for photography and he later became a videographer. Peter is a collector of old photographs from his home town, some of which are also featured in this publication.

Anne's grandson and co-author, Jake, is not camera shy either; a film graduate and actor he is comfortable on both sides of the camera, having worked as an extra on well-known television series such as *Vikings* and *Penny Dreadful* and on many independent films as both featured actor and filmmaker. Jake has also scripted, directed and filmed a number of music videos.

INTRODUCTION

Trim is the premier heritage town in County Meath. Founded in the fifth century, this picturesque town is steeped in history from its Norman past to the troubling events of the War of Independence.

Trim is dominated by the ruins of King John's Castle on the south bank of the Boyne. The castle is one of the finest surviving examples of medieval military architecture in Ireland. The great square keep, 75-feet high, with a tower projecting from the middle of each face, dates from around 1200. (The mount on which it stands is doubtless a remnant of the motte of Hugh De Lacy's original fortress, *c.* 1172.) The curtain wall enclosed about 2 acres. To the west of the castle, between Castle Street and Emmet Street and again to the west of Emmet Street, portions of the medieval town wall can be seen.

On the north side of the Boyne is Talbot Castle; a fortified house built in 1415 by Sir John Talbot. Now a private residence, the house served for a time as the Diocesan School of Meath. Many notable people were educated there such as Arthur Wellesley and Rowan Hamilton. To the east are the remains of the Yellow Steeple, the magnificent fourteenth-century bell-tower of St Mary's Monastery of Augustinian Canons Regular. The monastery is commonly held to have occupied the site of the ancient Episcopal monastic church of Trim. In the Middle Ages the monastery possessed a celebrated, miraculous statue of the Blessed Virgin (Our Lady of Trim) but this 'Idol of Trim' was destroyed at the Reformation. To the southeast of the steeple are the remains of the small Sheepsgate, the sole survivor of the town's five gates. On the south side of the river are the scattered remains of the Crutched Friary (Augustinian Hospitallers) of St John the Baptist.

The Boyne river flows through Trim. This river has been known since ancient times; the Greek geographer Ptolemy drew a map of Ireland in the second century that included the Boyne, which he called Βουουινδα (Bououinda), and somewhat later Gerald of Wales, writing in the twelfth century, called it *Boandus*. In Irish mythology it is said that the river was created by the goddess Boann. According to F. Dinneen, lexicographer of the Irish Gaelic language, 'Boyne' is an anglicised form of the name. In other legends, it was in this river where Fionn mac Cumhail captured Fiontán, the Salmon of Knowledge.

As Trim is a medieval town, nestled on the banks of the Boyne, its ancient beauty attracts lovers of history and art. Trim's unique scenery has been used as the backdrop for several major Hollywood films such as *Braveheart*, *Big Red One*, *The Blue Max*, and *Captain Lightfoot*. This landscape has also encountered many changes and facelifts over the years. Some were due to fires or flooding. Others were due to the changing times. Regardless of these changes, Trim has kept its medieval structures as intact as possible and the townspeople's appreciation of their surroundings sees Trim's beauty enhanced with every generation.

Anne and Jake have carefully selected the photographs for this book from thousands of possibilities to take the reader on a journey back in time to document a picturesque, community-driven town that takes pride in its history.

1

HISTORICAL TRIM

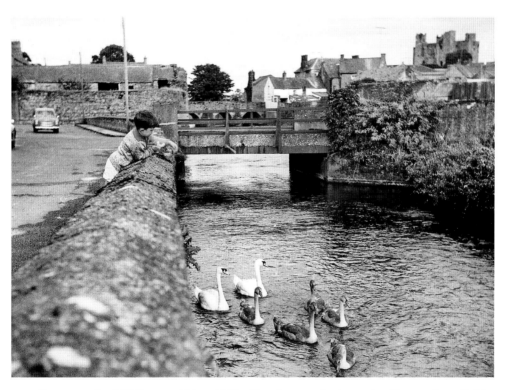

Swans on the Mill Race in Trim, 1961. The photograph shows Ian Dignam from Dublin (nephew of Trim resident Aileen O'Donnell), throwing bread to the swans. The flour mill was there from the 1700s. When Thomas Gilsenan purchased the property in 1937, the mill was already in ruins and was demolished in 1941, and the stones were used for road making. The Mill Race remained until 1970, when it was filled in as part of the Boyne drainage scheme in 1970. A stone in the remaining wall marks the spot where Patrick Flood was killed in an industrial accident in 1791.

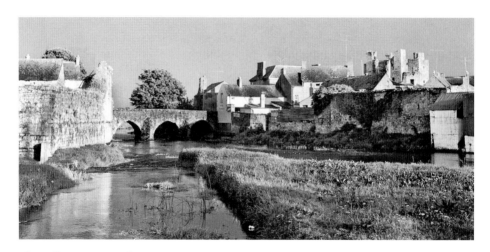

The Mill Race meets the Boyne in Trim, 1964. This is the site which gave Trim its name: *Baile Atha Truim* – The town of the Ford of the Elder Tree. A 'ford' is a shallow part of a river low enough to be waded through. On the left of the photo are the walls of the Old County Gaol. Some of the prisoners left their mark in the form of etchings on the stone walls. Michael Collier, a renowned highwayman, was eventually caught, tried and sentenced to death. While awaiting his sentence he was imprisoned in Trim Gaol. However, he escaped by climbing the wall and swimming the Boyne to freedom and he was soon waylaying the highway coaches again.

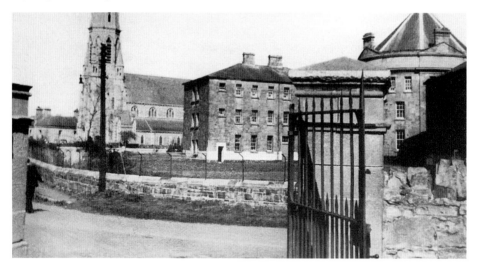

In 1834, a new County Gaol was built at a cost of £26,000 on the outskirts of Trim, opposite the workhouse. In 1837 Samuel Lewis described the new gaol – 'it consists of 5 ranges of buildings each divided into 3 storeys, the lower a dining hall and work room, 12 sleeping rooms or cells over. Between the ranges are airing yards for the respective classes who are employed in stone breaking or in various hand crafts, trades: in the centre is the Governor's house a circular building in the upper storey, of which is a chapel communicating with the five wards by a bridge leading from each. The prison is capable of receiving 140 prisoners in separate cells. It has a tread mill with two wheels, hospital for male and female patients and a school in which adults attend for three hours every day'.

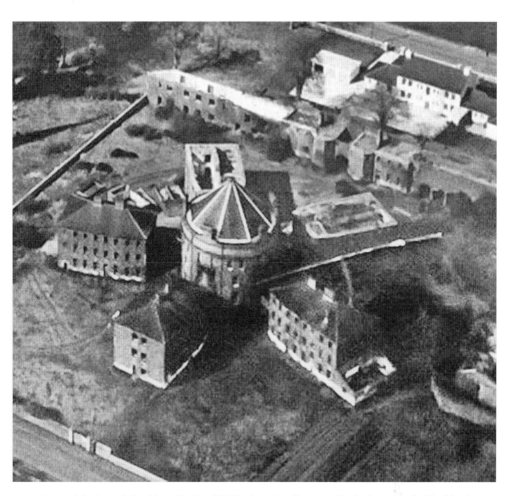

An aerial view of the New Gaol in 1951, showing the new Garda barracks behind it. A new Garda barracks was built and the gaol fell into disrepair, being subsequently demolished in 1953. During the demolition two men were killed as a result of an explosives accident. Michael Shiels of Marshallstown, Kilmessan, and Peter Smith of Castlemartin, Navan, were both employees of Meath County Council. Smith, an expert in the use of explosives, was preparing a charge of gelignite in a wall on the third floor of the building when the landing collapsed and the men were hurled 30 feet to the basement with a portion of the wall collapsing on top of them.

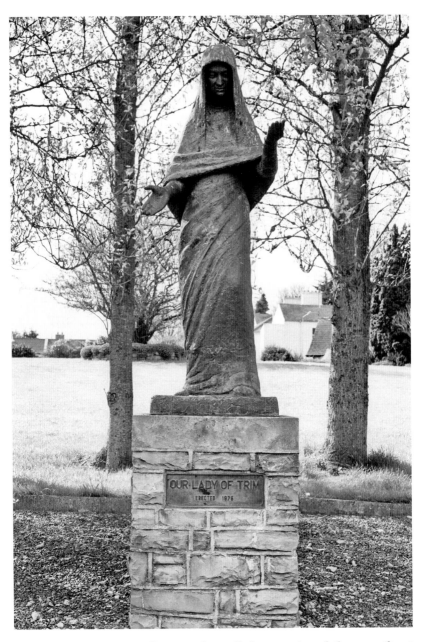

OUR LADY OF TRIM
ERECTED 1976

Our Lady of Trim. The Yellow Steeple is all that remains of the magnificent fourteenth-century bell-tower of St Mary's Monastery of Augustinian Canons Regular. The monastery is commonly held to have occupied the site of the ancient Episcopal-monastic church of Trim. In the Middle Ages, the monastery possessed a celebrated miraculous statue of the Blessed Virgin known as Our Lady of Trim. However, the 'Idol of Trim' was destroyed during the Reformation. A magnificent stained-glass window in St Patrick's church depicts pilgrims visiting the shrine. Local historian Revd Joe P. Kelly CC organised the erection of the statue in 1976, which is cast in bronze.

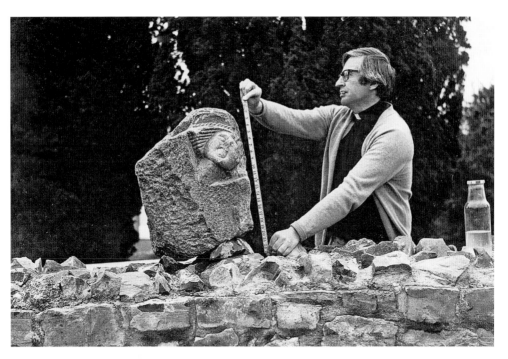

This stone head was discovered in the Maudlin graveyard during construction work for the erection of Our Lady Of Trim statue in 1976.

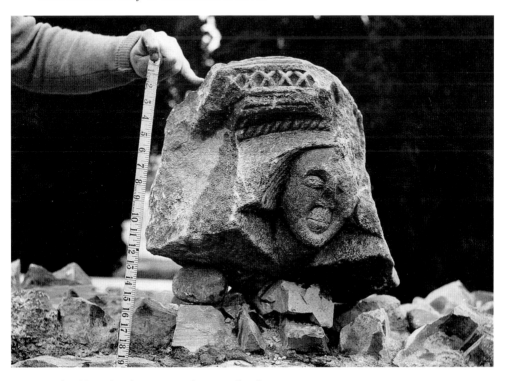

Fr John Moorehead measures the stone head.

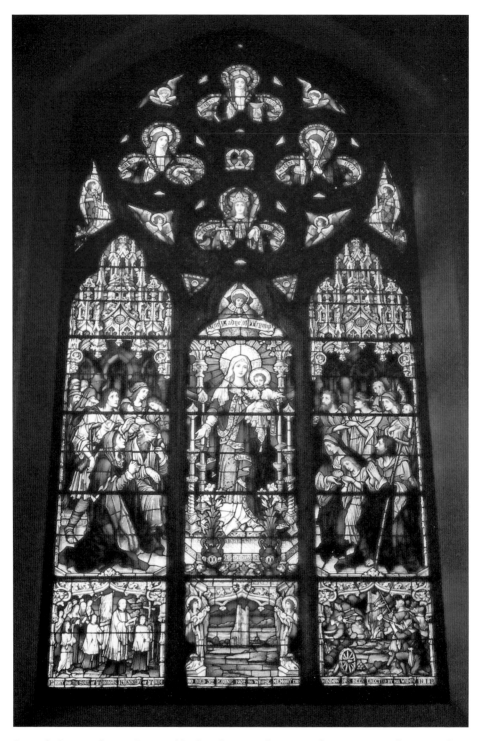

Stained-glass window in St Patrick's church, Trim, depicting pilgrims visiting the miraculous statue of Our Lady of Trymme (Trim).

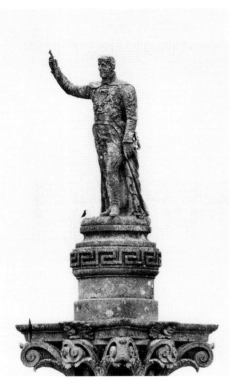

The Duke of Wellington Monument. Arthur Wellesley, 1st Duke of Wellington, sits atop of his 75-foot high Corinthian column. It was erected in the year 1817 in honour of the illustrious duke by the grateful contributions of the people from County Meath. It was erected on a corner of the Fairgreen, near where Wellington resided while secretary of Trim Corporation. Arthur Wellesley was the fifth son of Vicount Garret Wellesley of Dangan, 1st Earl of Mornington. Wellesley is regarded as one of the greatest defensive commanders of all time, and many of his tactics and battle plans are still studied in military academies around the world. After ending his active military career, Wellesley returned to politics. He was twice British prime minister as part of the Tory party and oversaw the passage of the Catholic Relief Act 1829, but opposed the Reform Act of 1832. He continued as one of the leading figures in the House of Lords until his retirement and remained Commander-in-Chief of the British Army until his death.

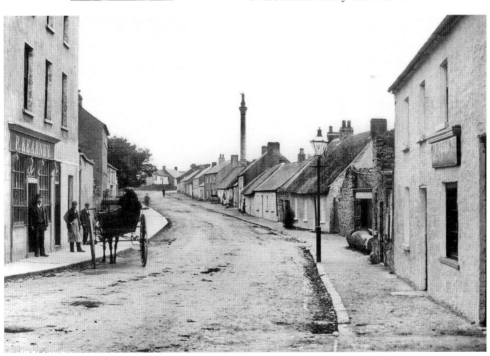

Wellington Street and Monument as it was in 1900, now known as Emmet Street. (Lawrence Collection, NLI)

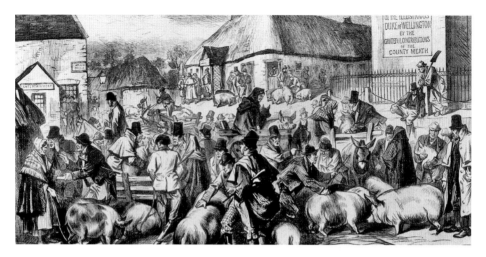

A sketch depicting the old pig fair, *c.* 1842. This sketch is from a book of Irish illustrations by William Makepeace. The sketch appeared in the *Illustrated London News* in May 1870. It was commonplace in that time for animals to be sold on the street. The foot of the Wellington Monument can be seen clearly, as can the entrance to what was formerly the Steps Pub.

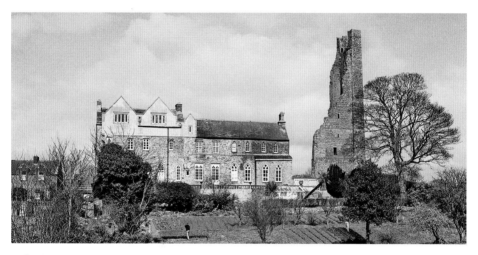

Talbot's Castle, a fortified manor house situated across the Boyne from Trim Castle. Talbot's Castle is also known as St Mary's Abbey, as the house occupies part of the site of this old monastery and is an adaption of the medieval monastic buildings. This was achieved by Sir John Talbot who was viceroy of Ireland in the fifteenth century. In the north wall of the west tower there is a stone bearing the Talbot coat-of-arms. On the south side is a stone plaque with the date 1425 on it. The building was converted into a school in the latter half of the eighteenth century. It served the Protestant community in Meath as a Latin school. Arthur Wellesley (later the Duke of Wellington) and Sir William Rowan Hamilton received their early education here. During repairs to a wall in the early 1960s, a series of rooms that had been filled in were found under the terrace. There is a trapdoor in one of the room's floors leading to the vaults below. In one of these vaults, there are stairs that lead to a dead-end, giving credence to the rumour that a tunnel went from the abbey to Trim Castle. The house is now the family residence of solicitor Peter Higgins, his wife and family.

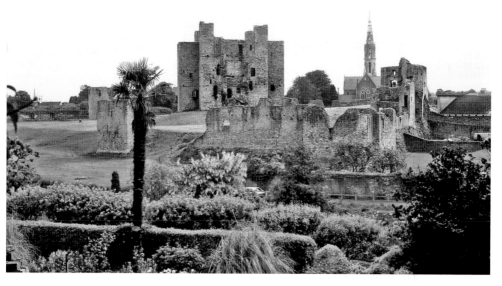

This photograph depicting Trim Castle, which is often called King John's Castle, was taken from across the Boyne at St Mary's Abbey. In 1172, King Henry II of England granted the Kingdom of Meath to Hugh de Lacy who chose Trim as his capital. Selecting a commanding position on a rise by the banks of the Boyne, de Lacy set about building the largest Norman castle in Ireland. It was designed to intimidate and dominate the native Irish. The castle guarded the northwest approach to Dublin and thus became the keystone of Norman power in this area of Ireland.

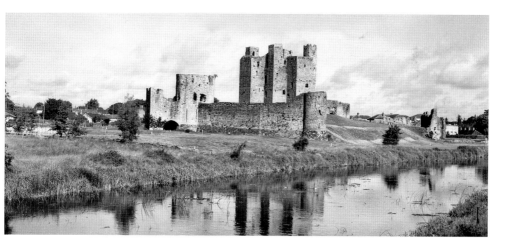

Trim Castle and River Boyne in the 1980s. The castle was occupied on a regular basis up to the middle of the fourteenth century. In 1403, the Privy Council in England stated that the castle was at the point of falling into ruin. Since then, the castle has lain abandoned except for a brief period in the 1640s when it was re-fortified. In 1971, an archaeological dig uncovered the remains of ten headless men, presumably convicts whose heads had been mounted on spikes and displayed on the castle walls. In 1993, the castle was purchased by the State and the following year became a film set for the film *Braveheart*.

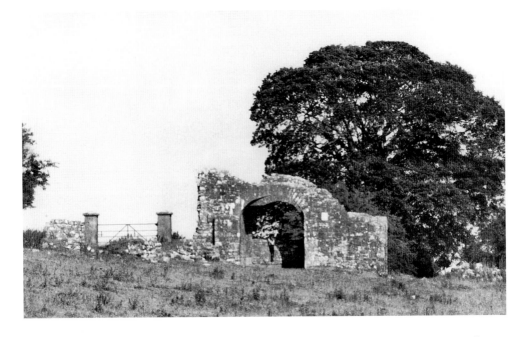

The Sheep Gate, 1964. This gate is the only surviving medieval gate of the town. It is situated on the north bank of the Boyne, close to the Yellow Steeple. In 1393 Roger Mortimer, Earl of March and Ulster, was granted the right to collect tolls and customs on goods being sold in the town. There were five gates into Trim: Dublin Gate, Watergate, Athboy Gate, Navan Gate and Sheep Gate. Over time the walls decayed and the remains of Dublin, Athboy and Navan Gates were removed in the nineteenth century. Watergate was removed to make way for the new bridge in 1900.

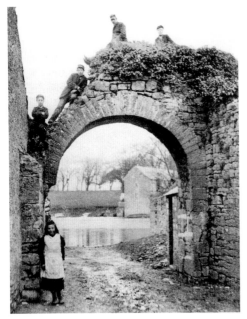

The Watergate was demolished for the building of the New Bridge in 1900. Through the arch across the Boyne you can see the gable of the mill, which was removed in 1941.

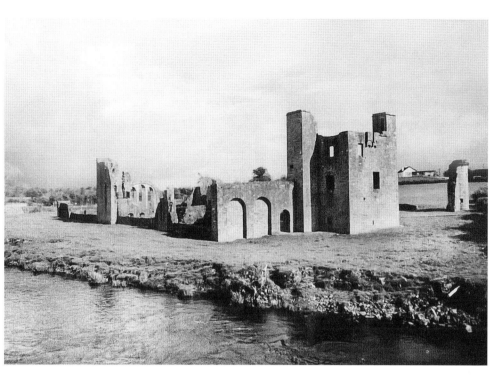

Priory of St John the Baptist. This priory, or hospital, was founded in the early thirteenth century for the Crutched or Crossed Friars Augustinian Hospitallers of the order of John the Baptist. It was built on the southern bank of the Boyne, beside St Peter's Bridge in Newtown-Trim, directly across from the Victorine Abbey. The three-storey, round watchtower at the roadside was originally 30 feet high and measured 42 feet around the base. The principal building is a square, castellated keep topped with two towers. The lower storey consists of a stone-vaulted kitchen complete with fireplace. A spiral staircase leads up to what once were the living quarters.

The first contemporary record of the priory is 1281, when there was a grant of alms from the manor of Magathtreth. In 1513, Edmund Dillon was prior of this monastery. Edmund was the brother of Thomas Dillon, who was prior of Sts Peter and Paul's church at about the same time. During the Suppression, the priory and its possessions were granted to their brother Robert, who later disposed of it to the Ashe family. They made their home in the main keep, making a number of structural changes to the building at this time. After being abandoned by the Ashe family, the keep was inhabited by Bishop Brown, Roman Catholic Bishop of Meath. After the Battle of the Boyne the building was granted to one of King William's men. During his first night in the building, he saw 'a most horrid vision' and at the dawn of day he sent for his horse and rode away, never to return.

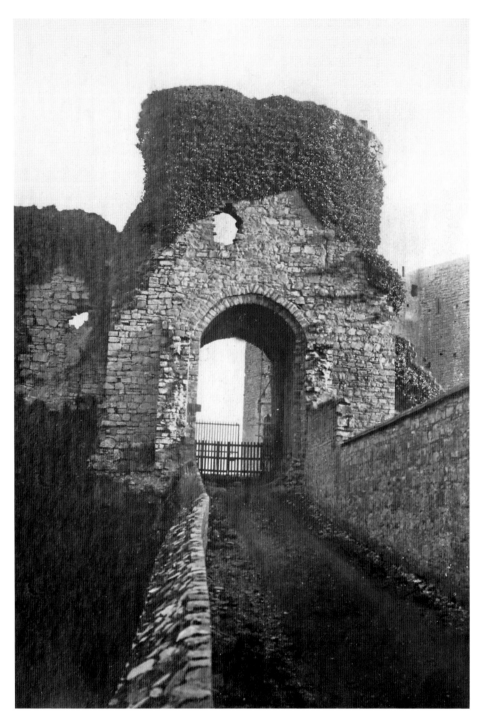

The Town Gate at Trim Castle, 1860. The Town Gate had a portcullis to protect it as well as a 'murder hole'. The other gate, the Dublin Gate, had a barbican projecting from the tower. Originally the barbican spanned the water-filled moat that surrounded the curtain wall and had a drawbridge which was operated from above.

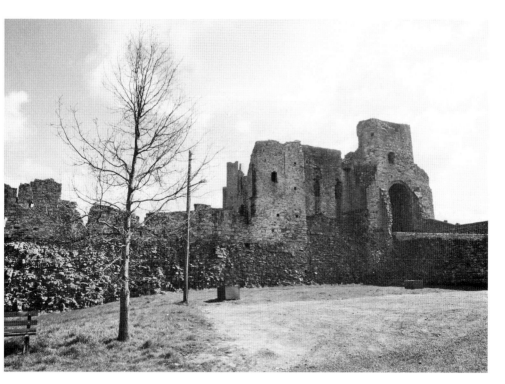

The Town Gate, 1980s.

The RIC barracks before its burning by the Black and Tans. Early on Monday, 27 September 1920, 200 Black and Tans entered the town of Trim, singled out the shops and business establishments of those residents alleged to be in sympathy with Sinn Féin, and ransacked, pillaged, and burned all. At noon, when a Navan correspondent visited the town, he stated that it 'had all the appearance of a bombarded town in the war zone of France'. Furniture was piled on the main street, houses were left smouldering, and the people were panic-stricken.

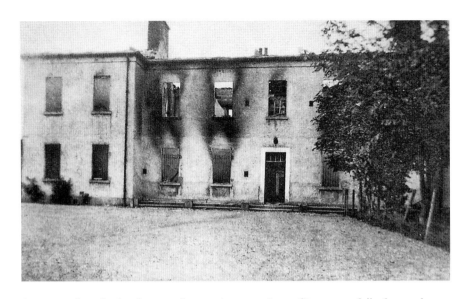

As reported in the local press, the previous evening military cars full of armed men had dashed into Trim on the way to the police barracks that had been burned by raiders that morning. Shots were discharged at a group of boys playing hurling on the green and a 16-year-old boy, George Griffin, was shot through the groin, while another named James Kelly was shot in the leg. The priests sought out some of the officers, gave them an assurance that the town would be quiet, and that all would be indoors by eight o'clock so the military departed. However, at three o'clock that morning a force of Black and Tans entered the town. They visited the Town Hall in Castle Street, a drapery establishment on High Street and a mineral water factory and licensed premises on Market Street. The doors were smashed-in, petrol was commandeered and poured over the shops, and soon all were on fire. The proprietor of the mineral water factory, who was also Chairman of Trim Urban Council, recalled that at a quarter to four in the morning the door was broken in. His assistants heard the noise and fled. The uniformed men called for the Chairman of the Council but he hid in the kitchen. They then went through the place setting the premises on fire. He estimated his loss at £20,000. In the drapery establishment, £8,000 worth of damaged goods and property is the measure of the reprisals. One of the two brothers owning the business was a member of the Urban Council. A tailor living on Castle Street, whose family were in bed, was taken into the street and asked where his Sinn Féin sons were. He replied he did not know. A bayonet, it is stated, was placed against his breast and a Black and Tan is alleged to have said, 'Put it through the beggar'. A postman appealed to the men to spare the old man. Then they smashed the door of his house, went through every room and destroyed every article in the place. All the residents on this street fled from their houses. The Town Hall was also completely destroyed and all the town records burned. At five o'clock the Black and Tans left, threatening to return that night to complete their work.

2

STREETS OF TRIM

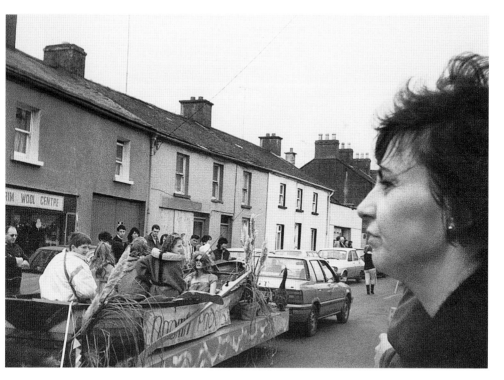

Emmet Street, *c.* 2005. Much has changed on this street in the last 10 years. The wool shop is now D. Mangan's Kitchen Centre while Harnon's, Brogan's house and shop were demolished and are now housing David Moore Photography, the Kitchen Café and Home Instead with apartments overhead.

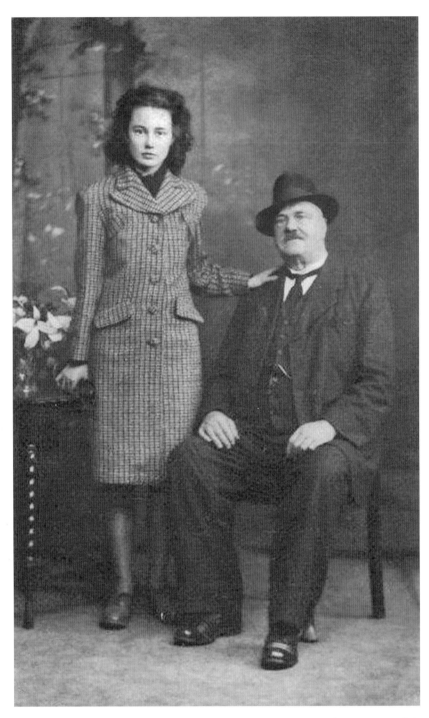

Pat Kearney with his daughter Olive, *c.* 1920. Kearney's owned what is now Kiely's pub in Emmet Street. Olive married Jackie Brogan and they were agents for Premier Milk and ran a high-class tobacconists, sweet and ice-cream shop across the road from the pub in Emmet Street.

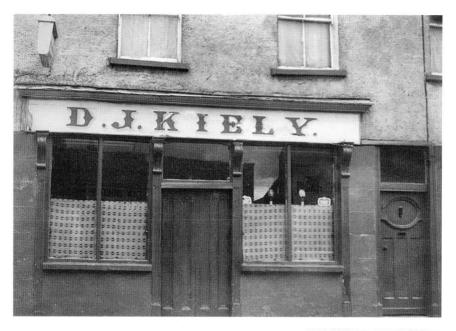

D.J. Kiely's pub, Emmet Street, 1971.

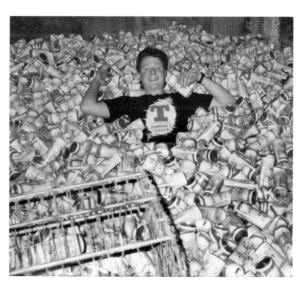

Jack Stenson and his dog Ben take a rest at Newtown-Trim during his daily walk, 1995. His father had a bicycle repair and sales shop in Emmet Street (now Fox's Bookmakers).

John Kiely celebrates the pub having the largest number of sales of 'Tennant's' in Ireland, 1987.

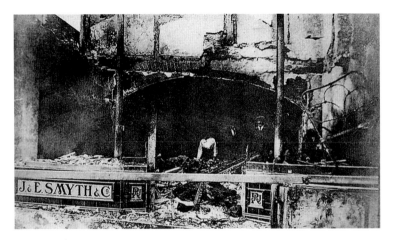

J. & E. Smyth's fire-damaged premises after the Black and Tans raid. It was reported that most of the houses on both sides of Market Street, the principal thoroughfare, were left burning.

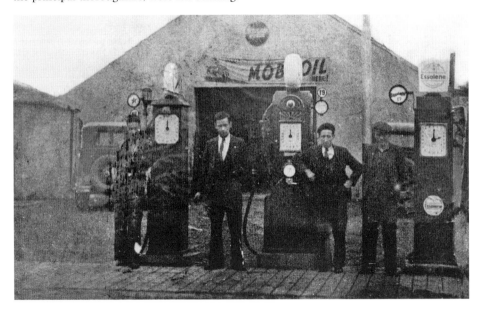

Smith's Garage, Emmet Street. Pictured are Michael Smith, Joe Smith, Paddy McManus, and Jack Quinn. Neville Preston Newman owned land and houses on 5 acres (8 statute acres) from Newhaggard Road to the former Smith's Garage on Emmet Street (then known as Wellington Street). This was sold to John Stuart (Earl of Darnley). On 31 October 1855, John Stuart sold this land to Bridget Gibney of Eccles Street, Dublin, for £650. On 7 May 1874, she sold the property to John Ledwith for £1,050. On 1 August 1924, Thomas Finnegan leased the garage portion of the property from Patrick J. Ledwith for 31 years at a rent of £10 4s 0d per year. On 6 October 1928, Thomas Finnegan sub-leased the premises to Thomas Lynch for £200. When Thomas Lynch died his wife inherited the lease and later bought the freehold. On 4 May 1931, Michael Smith, Kiltale rented the garage premises and field behind from Thomas Lynch. His two brothers Larry and Joe, and later his son Michael, worked with him and the business continued in the family for seventy-one years until July 2002.

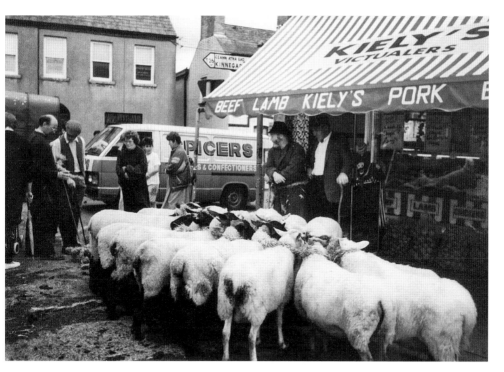

Fair Day in Market Street, 1992.

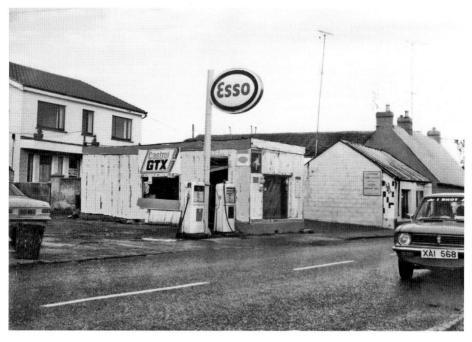

Smith's Esso Garage, Emmet Street, 1980. The building in the background of the photograph was formerly McEntaggart's Home Bakery and Undertaking business and is now Marigold Chinese Restaurant.

Smith's Garage and Lynch's shop/ pub, *c.* 1980s. In 1924, Lynch's pub was owned by Owen Darby. On 27 March 1925, he sold the licensed premises and garden to Thomas Finnegan for £300, which Thomas had borrowed from Henry Allen of High Street, Trim. On 1 March 1926, Thomas Finnegan sold the lease of the licensed premises to Thomas Lynch. The lease was for sixty-one years from 1 November 1874. Rose Lynch bought the freehold of the pub at the same time as the above-mentioned garage.

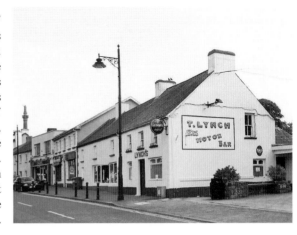

Paddy McManus, relaxing on a car in the forecourt of Smith's Garage, Emmet Street, 1932. Darcy's House is in the background, where Potterton Auctioneers is situated, and the wall is where Francie Martin's Jewellers now stands.

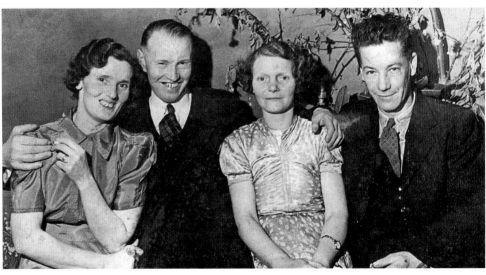

Mrs McGonagle and her husband Hugh, with Annie Smith and her husband Michael, *c.* 1935. Hugh was proprietor of Mac's shoeshop in Market Street and Michael was proprietor of Smith's Garage, Emmet Street.

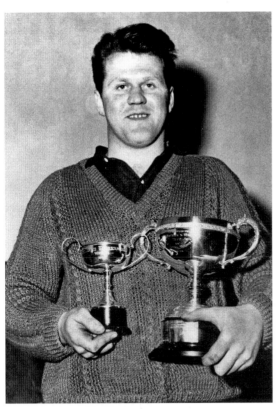

Liam Anderson, billiards champion in 1960 and 1963, in St Patrick's Hall, Patrick Street, 1963.

Trim Vintage and Veteran Rally Committee, Bridge Street, 1996. From left to right, back row: Bobby O'Brien, Frank Pratt, Michael Allen, Michael McCormack, Ollie Hughes, George Douglas, Raymond Lynch, Christum Leonard. Front row: M. Loughran, Betty McEvoy, Angie Brogan, Iris Wilson, Margaret O'Loughlin.

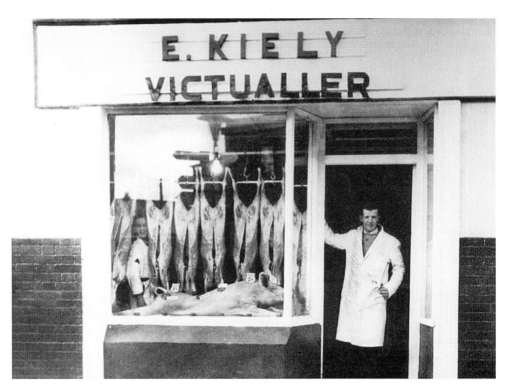

Eugene Kiely outside his butcher's shop, Market Street, 1958. Eugene started the successful business that is continued by his son.

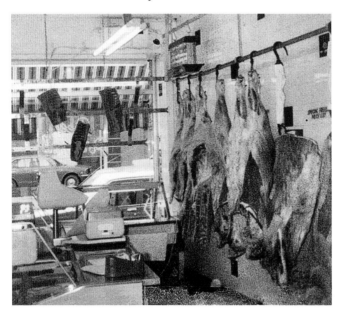

Interior of Eugene Kiely's shop, Market Street, 1958. Meat can no longer be displayed as it is in this photograph; it is now required to be stored in refrigerated display.

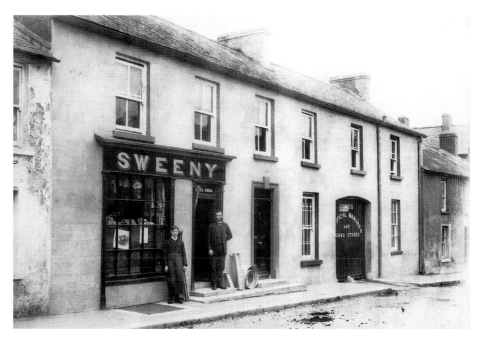

William Sweeny at the door of his pub on Castle Street, Trim. The apprentice on the left is Tommy Lynch, who later owned a pub in Emmet Street, and his grandson Fergal now runs it. William was an Urban Councillor for many years and was a director of Torc factory. He died on Christmas Day, 1938, while cycling home to his farm at Galtrim. The pub changed hands many times over the years. Loughran's purchased it in 1939. Jack Halpin and John Fox renamed it the Castle Arms. Pat Carney then took over from 1978 followed by Kerr Reilly in 1983. It is now known as McCormack's, after the current owner Martin McCormack.

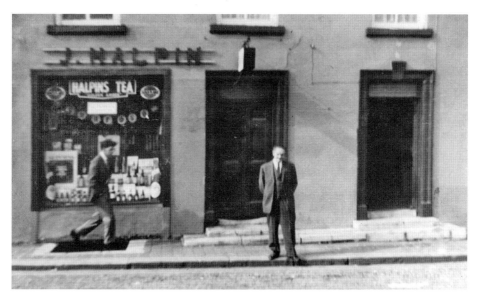

Jack Halpin outside the same premises on Castle Street. Halpin also had a grocery shop on High Street, run by his daughter Olive. Their shop was the first to sell bottled milk in the town.

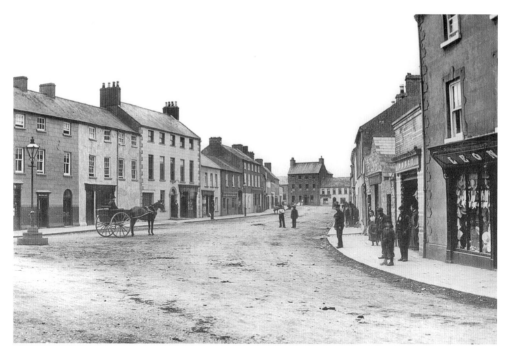

Market Square, *c.* 1914. The Lawrence Collection, in the National Library of Ireland, consists of 40,000 glass plate negatives from 1870 to 1914. The images were produced commercially and captured scenes of that period throughout Ireland. The majority of the photos were taken by Robert French, the Lawrence Collection chief photographer.

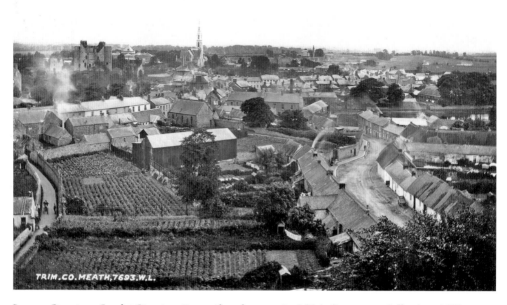

Loman Street, or Scarlet Street as it was then known, in 1914. (Lawrence Collection, NLI)

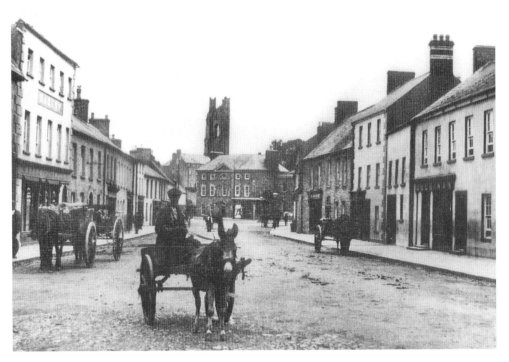

Market Street, *c.* 1914. (Lawrence Collection, NLI)

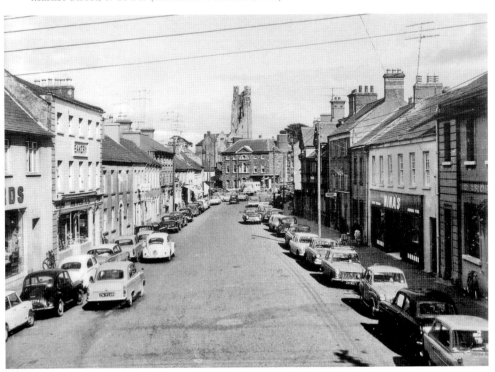

Market Street, 1972.

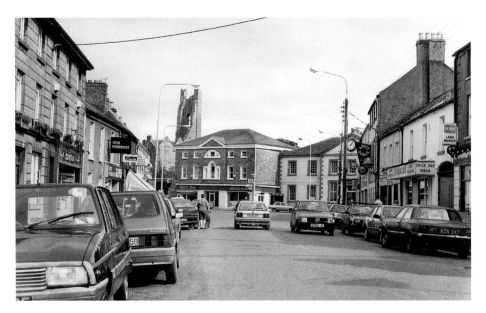

Market Street, 1992.

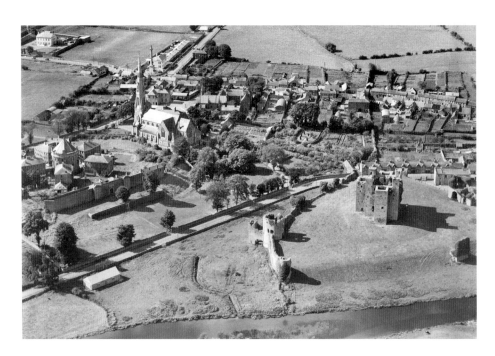

An aerial view of the north bank of Trim, *c.* 1950. This photograph predates the building of the Garda barracks that currently sits opposite the barbican of Trim Castle. In the bottom left of the photograph, a small white building can be seen; this was the British Legion Hall that was used for many activities including badminton. Near the British Legion Hall, the Leper Stream can be seen. When the foundations for the Garda barracks were being built, the workers came across the Leper Stream which held up construction for some time.

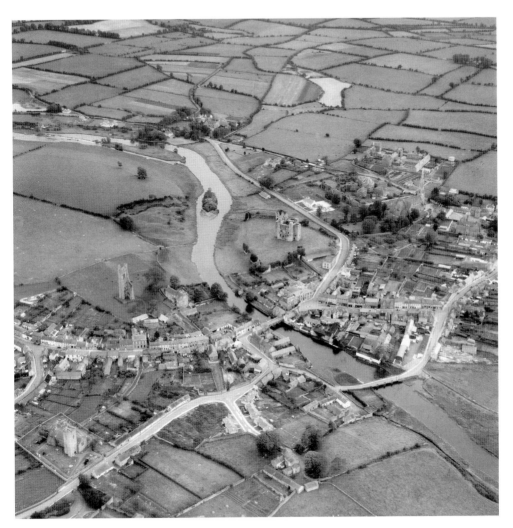

A larger aerial view of Trim, *c.* 1952. In the centre of this photograph, the newly built Garda barracks can be seen opposite Trim Castle. The River Boyne is divided, as seen at the bottom of the photograph, as the river used to power the mill.

Trim Pitch and Putt Club, *c.* 1970 (prior to it being moved across the bridge from Mill Lane to Canty's Bottoms). Ray Crinion (left) presents a trophy to Richard (Dick) Wheeler.

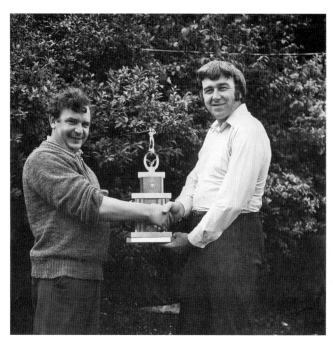

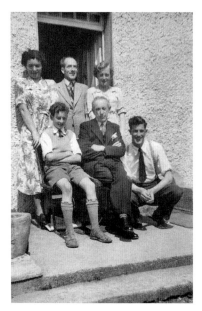

The Mill House, Mill lane. From left to right, back row: Betty Taffe (Hibernian Bank clerk)Joe Gaughran (visitor) Brid Brennan (teacher). Front row: Matt Gilsenan, Thomas Gilsenan, Frankie Tighe (Ulster Bank clerk). Thomas and Christina Gilsenan ran this well-known guest house in the 1940s and 1950s. Residents would get full board and many well-known names stayed there over the years. T.P. McKenna, a stage actor and film star, stayed there before he left the Ulster Bank to pursue his acting career. While in Trim, McKenna played the part of a blind man in a play called the *Paragon*. It was a time before television in Ireland and this boarding house was a hive of music; residents were free to play the piano and family and friends joined in with the entertainment. Today the house is still occupied by family members.

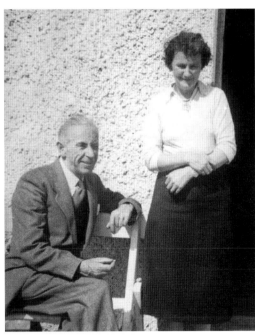

Thomas and Christina Gilsenan outside their home, Mill House. Thomas was the District Court clerk while Christina was a nurse before her marriage to Tom in 1935.

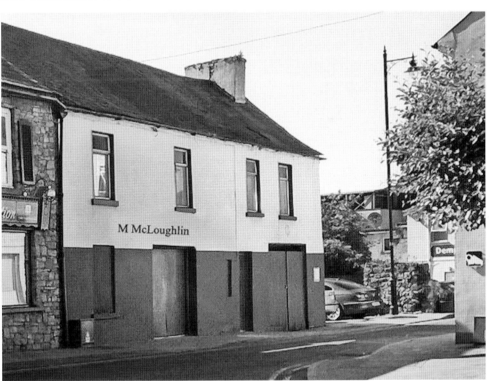

Michael (Mixie) McLoughlin's cycle shop on Bridge Street, c. 1980. Michael's father owned the first taxi in Trim. Michael owned the cycle shop until he retired. Currently, the Leinster River Rescue operate out of the premises.

Michael Mcloughlin
in 1989.

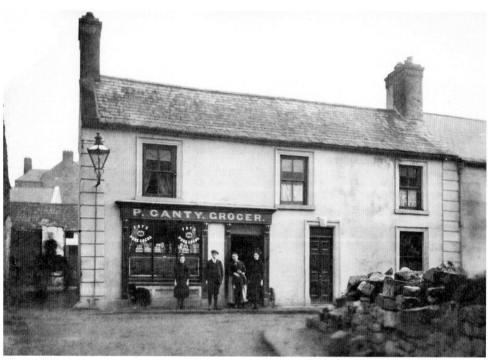

P. Canty pub and grocery, Bridge Street, *c.* 1900, which is now the Bounty Bar. Rose Canty is the young girl in the photograph with her mother Helena, her father Pat, and brother Tom. Rose eventually ran the pub and grocery for many years.

3

THE BOYNE

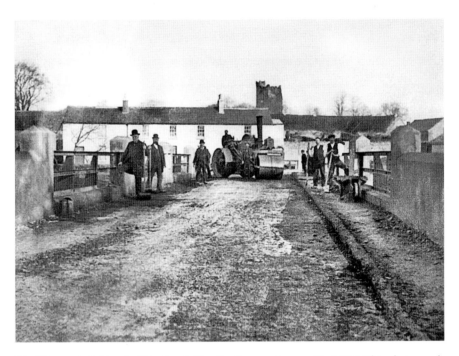

The Watergate Bridge, built by the Collins Brothers and opened in 1903. This photograph shows a steamroller at work finishing the surface. It was replaced in 2003 by the present bridge.

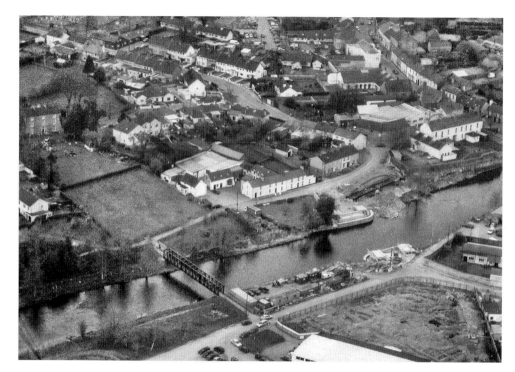

Aerial view of the river without the old bridge as the new one is ready to be lifted into place. It was built by The Coffey Group, Athenry. Roughan and O'Donovan designed the landmark steel bowstring bridge to replace the 100-year-old bridge.

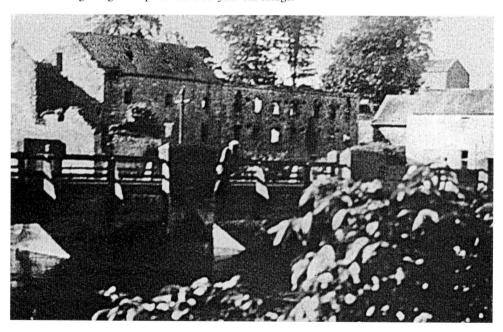

The Flour Mill at Mill Lane on the north bank of the Boyne. Already in ruins, it was demolished in 1941.

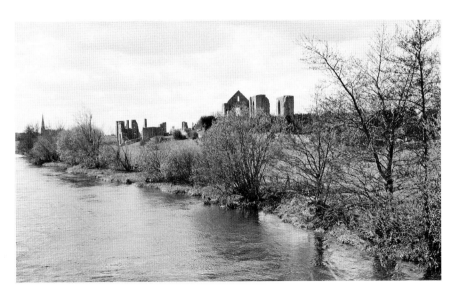

On the north bank of the Boyne at Newtown Trim are the ruins of the medieval cathedral of the diocese of Meath. The see was set up here in 1206 by Bishop Simon de Rochfort, who confided the services and fabric to a community of Augustinian canons of the Congregation of St Victor of Paris. From this fact and from the dedication of the cathedral, the ruins are commonly but erroneously called Sts Peter and Paul's Abbey, also referred to as Newtown Abbey. The cathedral was destroyed by fire in the Middle Ages, and the nave-aisles and transepts were never rebuilt. The ruins therefore represent, in the main, the choir and a short portion of the nave of de Rochfort's church.

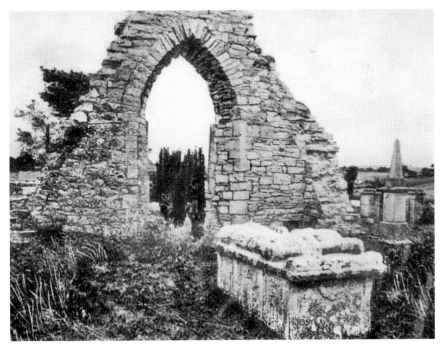

The tomb of Sir Lucas Dillon at Newtown-Trim.

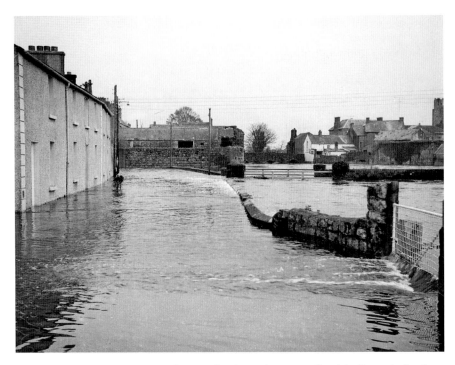

In 1954 and 1965, the Boyne burst it banks and Trim suffered badly with flooding. This photograph shows Mill House and Mill View under water. The resident guests in Mill House had to be rescued and brought to alternative accommodation. The water was not at its full height in this picture; Mill Lane was totally impassable and the residents had to climb over fences and exit on foot via Sarsfield Avenue, situated behind Mill House.

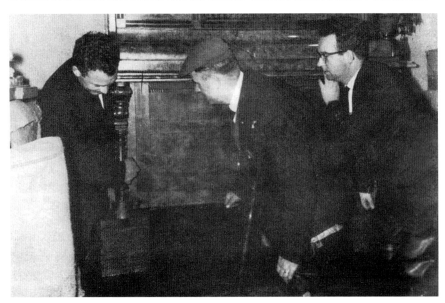

Ray Crinion, J.J. Fallon, and Matt Gilsenan attempting to save the piano from the floodwaters by lifting it onto cement blocks in Mill House, 1965.

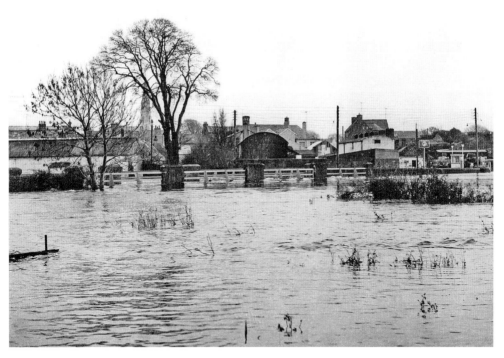

Watergate Bridge under flood waters 1965.

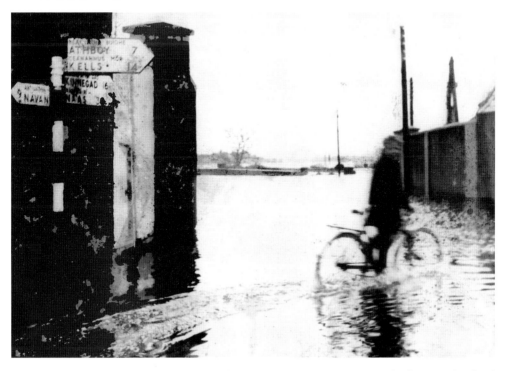

Molly Lynch, from Athboy Road, makes her way home on her bicycle through the flood
waters in Trim, 1965.

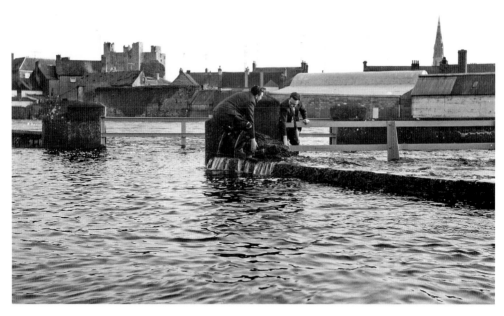

The River Boyne in flood on Watergate Bridge, 1965. Matt Gilsenan and Tom Dempsey can be seen attempting to salvage something from the water.

During the floods of 1965, a fire broke out in John Spicer & Co. Ltd Bakery, Watergate Street. No lives were lost; however, it took great lengths to access the building to quench the flames and extensive damage was caused.

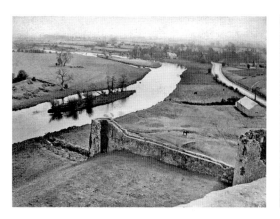

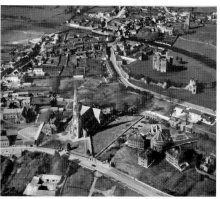

The River Boyne, 1937. The British Legion Hall is visible in the castle grounds and the drawbridge has the water flowing under it.

An aerial view of Trim, 1951. This photograph shows the drawbridge and the new church clearly as its spire dominates the landscape. A cannon, that was situated behind the Garda barracks, was relocated to the grounds next to the entrance of Trim Castle.

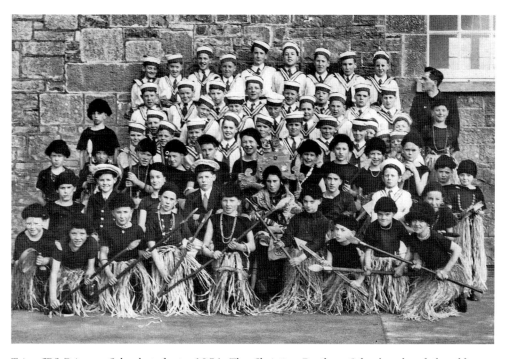

Trim CBS Primary School students, 1954. The Christian Brothers School replaced the old Model School which was an imposing building, at a cost of over £16,000. The building, now known as The Boyne Community School and no longer run by the Christian Brothers, is picturesquely situated on the banks of the Boyne, hence its name.

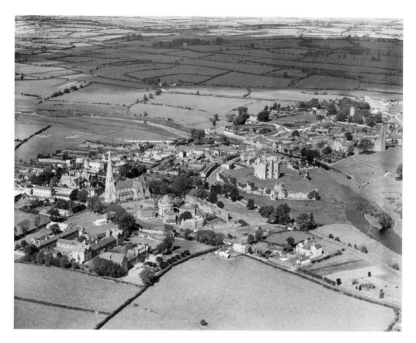

An aerial view of the Boyne river flowing through Trim.

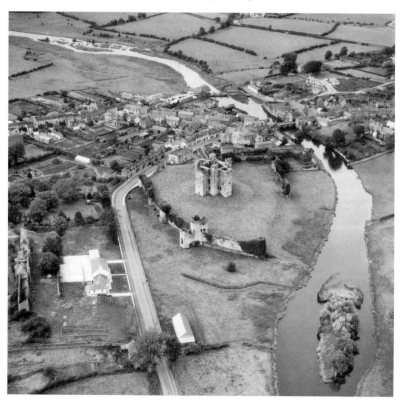

A sky view of Trim's ruins and river.

4

THE PARISH
OF TRIM

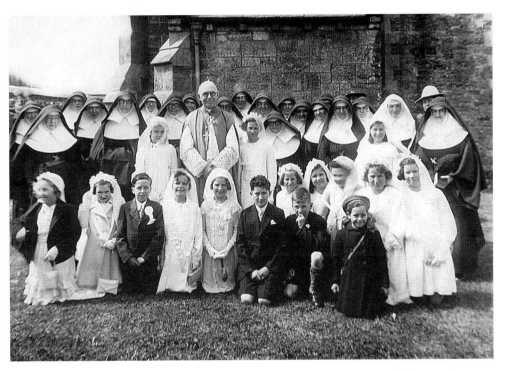

Bishop John Francis D'Alton was Bishop of Meath 1943–1946. This was his last Confirmation in Meath in St Patrick's church, Trim, before his elevation to cardinal. Some of the children in the photograph are Kathleen and Frances Andrews, Marie Gilsenan, and Pat McGonagle. Sister of Mercy nuns included are Sisters Gabriel, Alphonsus, Gertrude, Dympna, Bernadette, Josephine, Carmel, Columba, Dominic, Aquin, Philomena, Gerrard, and Brendan.

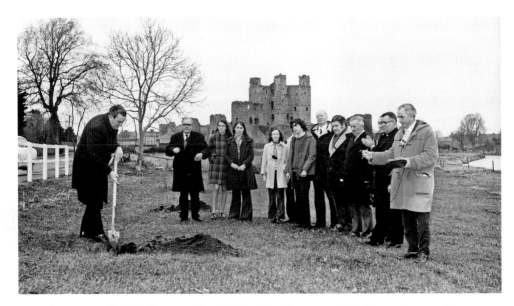

Tree planting at the Maudlins, in the 1970s. Tom Dempsey with Jimmy Gogarty (Town Foreman), T.J. Mekitarian (Engineer), Derry Dwyer, Austin Sharkey (County Manager), Revd Joe Paul Kelly, and well-known *Meath Chronicle* journalist Gareth Fox, all watch over the proceedings.

Mons Sean Kenny at the blessing of the site for St Michael's New National School, *c.* 1985. From left to right, back row: Marian Kelly, Lily McGee, Ann Dempsey, Ita Mekitarian, Grainne Kelly, Sharon Molloy, Mons Sean Kenny. Middle row: Suzanne Dwyer, Carol Dempsey, Siobhan Murphy, Aoife Kearney, Mary Owens, Olga Dorris, Ciara McGee, Tina Fagan, Sarah McGonagle, Mary Bligh, Jill Merrick. Front row: Sinead Fox, Ella Tighe, Tina Leonard, Sara-Jane Bird, Grace Kiely, C. Griffin, Emma Dowling, Philippa Cantwell, Annie Quinn, Denise Dunne, Bernadette Walsh, Tracey Kerrigan, Tina Fagan, R. McGonagle, Niamh Fitzsimons, and her sister.

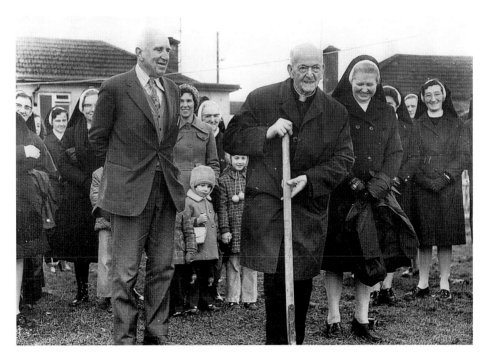

Vincent Eivers and Monsignor McKeever with the Sisters of Mercy, cutting the first sod on the site of St Mary's National School, 1973.

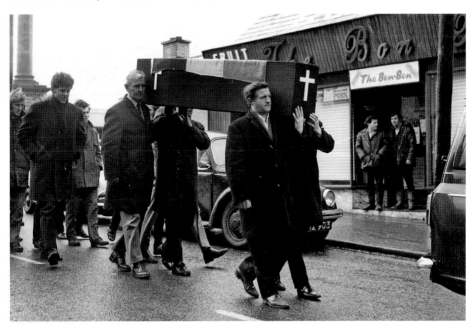

The Peace March in Trim, 1972. Local community groups gather and march to voice their condemnation following the Bloody Sunday carnage in Derry. The two visible pallbearers are Ollie O'Reilly and P.V. Dunne. Following the coffin are, from left to right: Michael Fay, Michael Connor and Harold Rayfus.

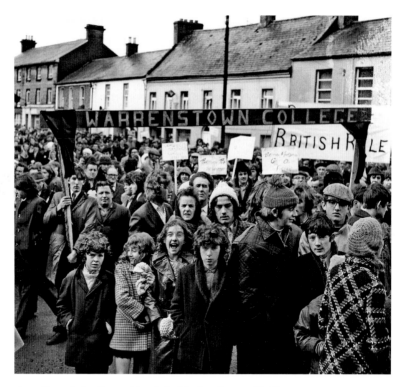

A section of the Peace March in Market Street, 1972.

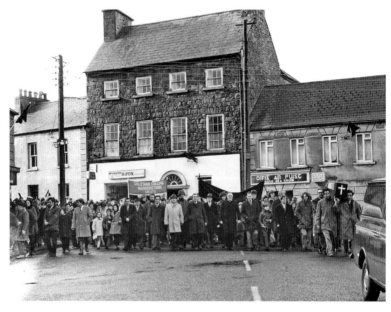

Members of the Urban Council, GAA Club and other organisations lead the
Peace March down Market Street, 1972. Included in the photograph are
Joseph Gaughran, UDC Tom Dempsey, UDC Jimmy Dolan, UDC Cyril Reilly,
UDC Bill Allen, UDC Garda McGeough and Peter Darby.

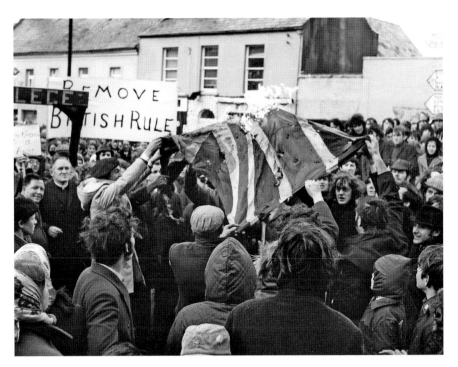

The Union Jack was set alight in Market Street, 1972.

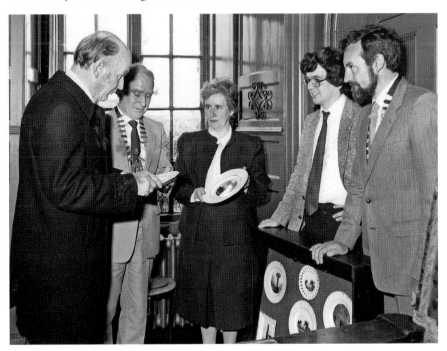

President Patrick Hillary in St Mary's Abbey, 1982. From left to right: President Hillary, Michael A. Regan, Anne Crinion (the author), Peter Higgins and Brian Kelly. Anne was presenting the President with one of her decorative China plates.

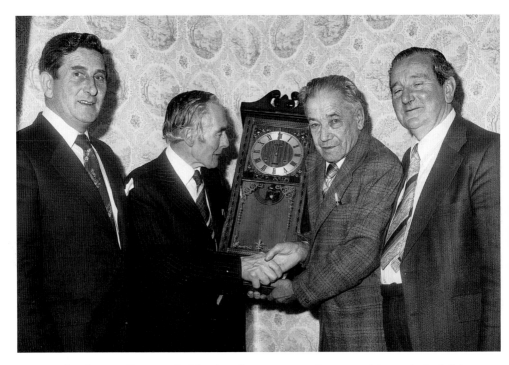

Past pupils of Trim Vocational School make a presentation to retiring principal John McDonnell, *c.* 1970. From left to right: Frank O'Brien (County Manager), John McDonnell, Michael Smith, and Tom Dempsey.

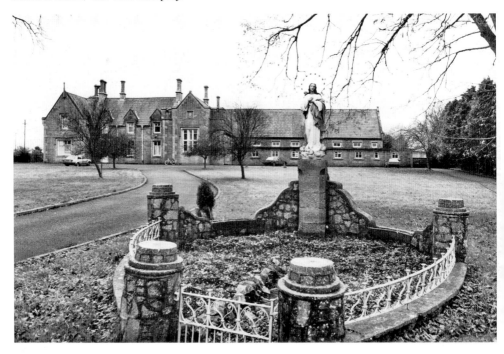

St Michael's Primary and Secondary School, 1993. It is now the Boyne Community School.

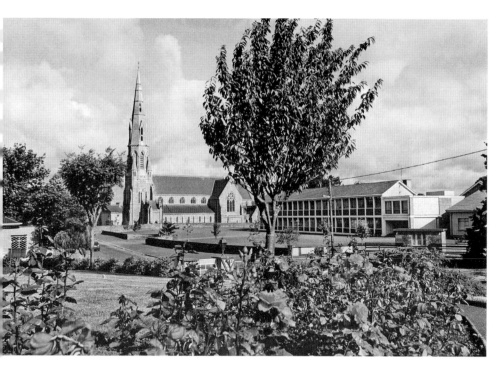

Scoil Mhuire secondary school for girls. It was built by the Sisters of Mercy in the 1960s on the site of the Old Gaol. Beside it is St Patrick's church which was opened in 1903. The building was delayed for a few years due to the Parnellite split.

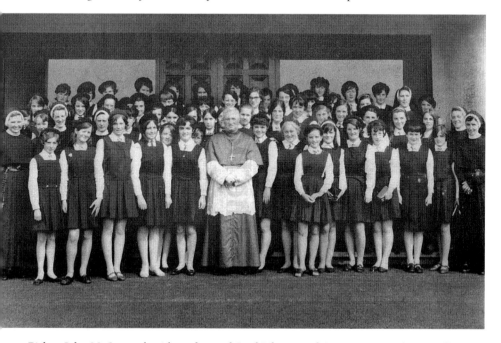

Bishop John McCormack with students of Scoil Mhuire and Sister Concepta (Principal), Sister Columba, Sister Brid and Sister Francis at the official opening of the school in the 1960s.

St Joseph's Community Nursing Unit, originally known as the Workhouse, was built in 1841 under the direction of the Poor Law Guardians. It was an attempt to meet the needs of the poor and the destitute at the time of the Famine. In 1884, at the request of the Poor Law Guardians, two Sisters of Mercy, Sister Aloysius King and Sister Teresa Kealy, responded to the need. They were followed in 1921 by Sister Francis Clyne and Sister Antonio O'Brien. In the 1900s, it came under the management of the Board of Health and later the County Council and became known as the County Home.

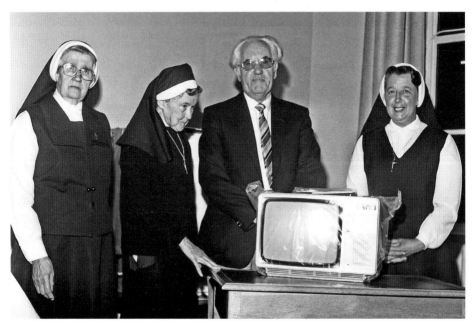

St Joseph's Hospital, 1987. Sister Oliver Byrne (retired matron), Sister Dominic Sheil (retired matron), Michael Conroy at his retirement and Sister Carmel Mulligan (matron).

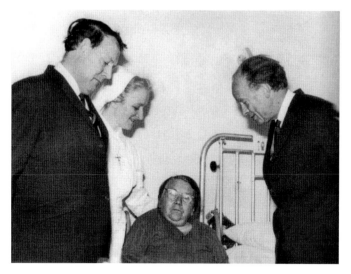

President Erskine Childers visits St Joseph's in 1973 accompanied by Dr Larry McEntee and Sister Josephine McNamara.

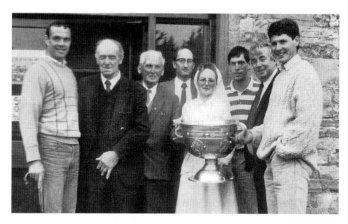

Sam Maguire visits St Joseph's Hospital, 1987. From left to right: Mick Lyons, Tom Gannon, Mr O'Donovan, Dr Gibbons, Sr Camillus (holding the cup), Frank Foley, Seán Keelan, Michael McDonnell.

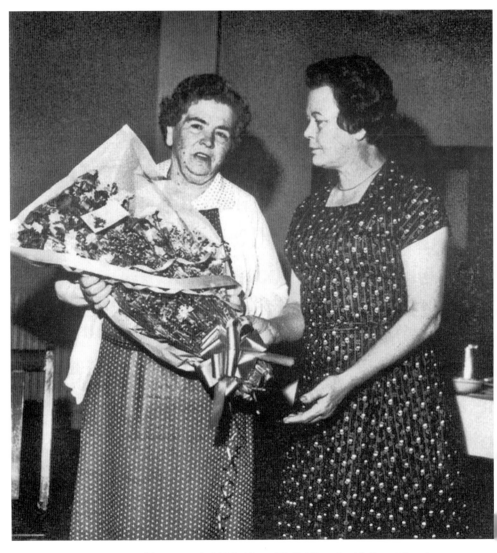

Staff retirement at St Joseph's Hospital, 1983. Mary (Molly) Dowd with Rose Maguire.

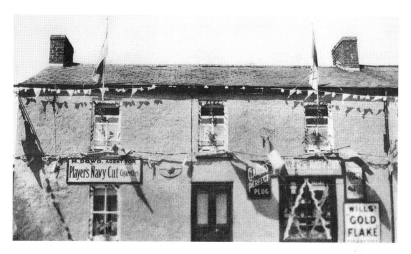

Bunting and banners for the feast of Corpus Christi at the Castle Restaurant, Castle Street, in 1930. Each year on the feast of Corpus Christi a procession took place in Trim. It started in St Patrick's church with the Blessed Sacrament carried in a monstrance under a canopy held by four men. Girls dressed in their first communion dresses carried baskets and dropped flower petals on the road.

Maurice Dempsey's tailor's, attached to the restaurant, was also decorated, 1930.

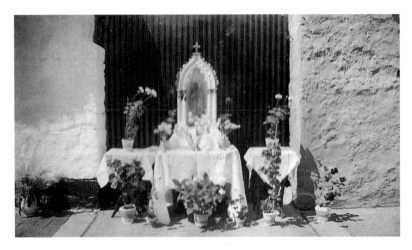

An altar sits outside the Castle Restaurant in 1930. For weeks leading up to the procession, the houses and shops on the route of Patrick Street, Market Street, and Castle Street would be painted. The town became a feast of colour with banners, flowers and bunting decorating the streets and statues placed in the windows of shops and houses. Local volunteers, when erecting the signs for Corpus Christi, aptly placed signs to link quotations to the local businesses; such as 'I am the Bread of Life' outside Spicer's Bakery, and 'My flesh is Meat Indeed' outside a butcher's shop. A PA system broadcast the rosary and hymns from a direct link to the church so the people of the town could hear it on the procession route. Great crowds would attend and the procession ended with outdoor benediction at the church.

Sr Mary Alban Dowd with her mother Mary Dowd and her sister Margaret Dempsey outside the Castle Restaurant on Corpus Christi, 1930.

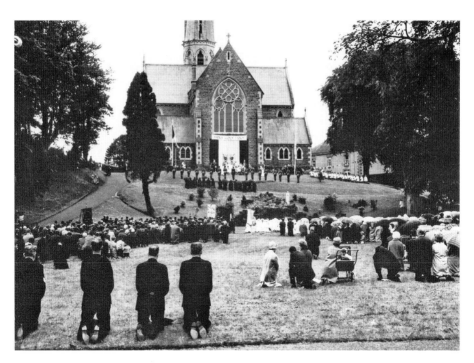

Outdoor benediction at St Patrick's church, Corpus Christi, 1971. The FCA provided a guard of honour.

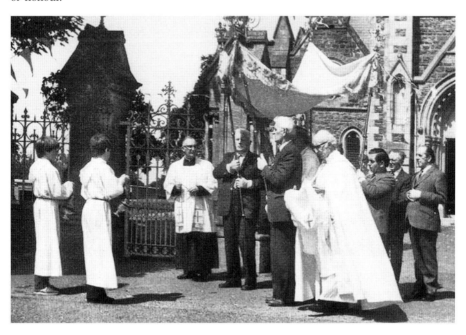

Corpus Christi procession, 1974. Assisting Fr Bird and Mons Kenny with the Corpus Christi procession are Tom O'Byrne, Ollie O'Reilly, Tom Brogan, Jackie McCormack and Frank Reilly. The mass servers in the left of the photograph walked backwards with the thurible, a metal container suspended from chains in which incense is burned during worship services.

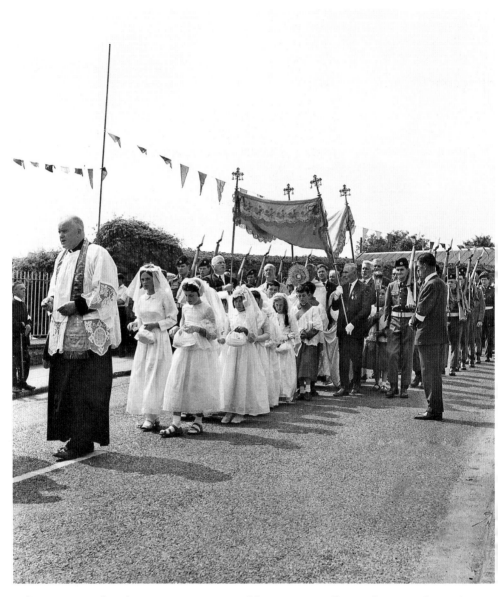

Jack Mooney watches the procession, 1970. Led by Fr James Holloway, they pass the nun's garden wall, which predates Davy's and Gilroy's bungalows, and is now where Trim Castle Hotel stands.

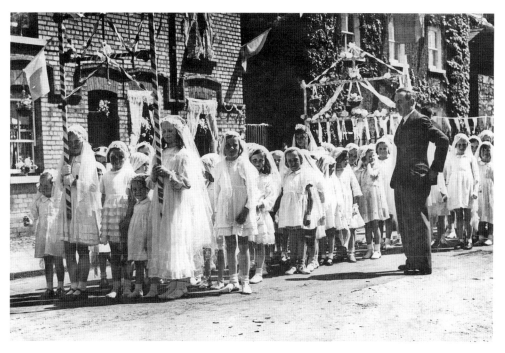

Thomas Gilsenan acts as a steward at the 1946 Corpus Christi procession as it proceeds down Emmet Street.

The 1980 Corpus Christi procession proceeds down Patrick's Street. The small houses are decorated with flowers and holy objects.

Irish dancers, 1954. The dancers would have trained at St Patrick's hall which is the parish hall beside St Patrick's church. From left to right, back row: John Gilligan, June Brogan, Angela Farrell, James Brogan. Front row: Mary Magee, Philip Lacy, Michael Smith, Joan Wallace.

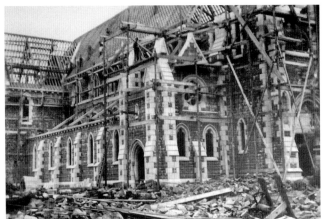

St Patrick's church during its construction in 1896. St Patrick's is a Gothic Revival-style church, built *c.* 1900. The church is surrounded by landscaped grounds that overlook Trim Castle. Celtic mosaics decorate the interior of the church. The mosaics' designs are replicated from the Book of Kells. The church features a white marble altar, the masonry work of the family of Pádraig Pearse, and stained-glass windows depicting the history of Trim. Overall the church is a very imposing building. There is a renowned pipe organ situated on the choir balcony that is serviced by a lift. The scale of the church provides excellent acoustics and a sizeable congregation of 800 can be accommodated in the church.

5

TOWNSPEOPLE

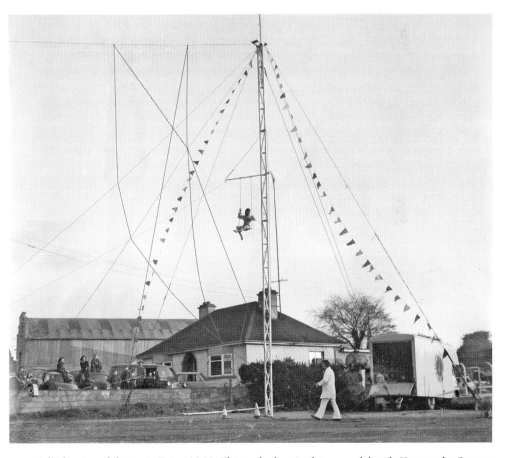

A high wire exhibition in Trim, 1968. This took place in the car park beside Kavanaghs Garage, Watergate Street. The event pre-dates current Health and Safety regulations. The stuntman rode a motorcycle across the wire and then climbed to the top of the very high mast.

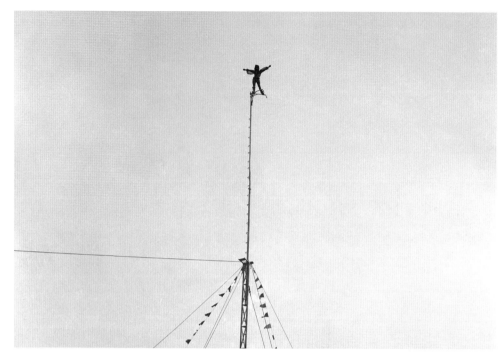

On top of the world, 1968. The mystery-man stands on top of a very high mast. The public could see the event free of charge.

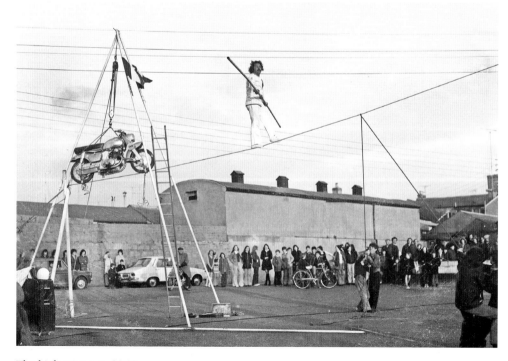

The high wire act, 1968.

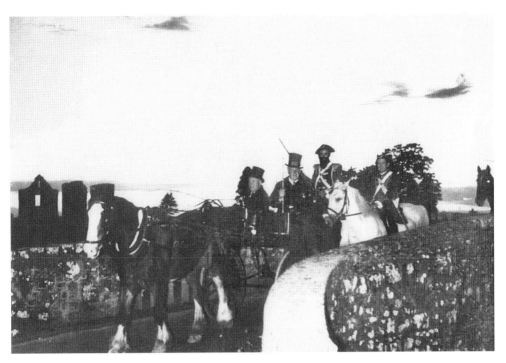

Local man Bill White and friends drive horses over the Newtown Bridge in 1969 as part of a re-enactment of the Evictions of Rathcore for Scurlogstown Olympiad Festival.

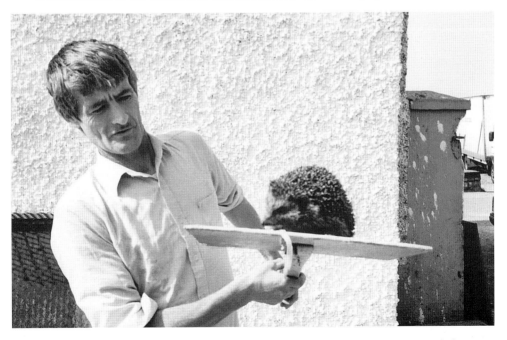

Jimmy Coogan rescues a hedgehog at Mill Lane, 1996. Jimmy worked for Crinion's furniture at Mill Lane and was affectionately nicknamed 'Bun' Coogan as he started his working career in Spicer's confectionary and bakery.

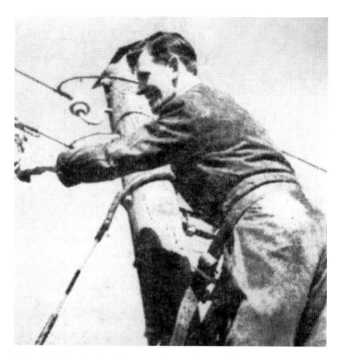

Ollie O'Reilly, 1951. Ollie was the ESB line-man in Trim for thirty years, succeeding his father Phil, who held this position before him. He was a one-man institution in those years. He climbed the poles, read the meters and collected the money. Born in Kells in 1921, Ollie moved to Trim with his family when he was 6 years old. He played hurling and won a record eleven Senior Hurling Championship medals for Trim. In addition, he played and captained the Meath Senior Hurling team for a number of years. He also had a superb singing voice and was a great addition to both the Trim Musical Society and church choir.

Meath won the All-Ireland Football Championship in 1949 and a reception was held for them in the Town Hall in Trim. From left to right: Joe Gilsenan, Matt Gilsenan and Anne Gilsenan.

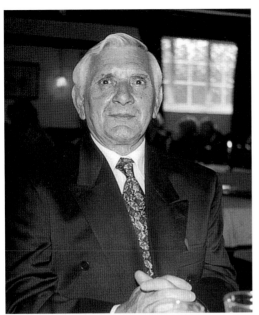

Victor (Vicky) Douglas. Although too young to have been included among the founding members of Trim Musical Society, Vicky Douglas came on the scene when both he and the society were in their formative years. According to many locals, Vicky's remarkable tenor voice was discovered by his pal Sean McNulty while out for a walk around Newtown. Sean, being the son of pianist Kathleen McNulty, wasted no time in inviting him for a music session with his mother and her piano. News of the vocal discovery travelled like the proverbial wildfire. Vicky's daughter Judi recently stated that her father went on to train under the legendary Dr Vincent O'Brien who had also guided the legendary John McCormack in his formative years.

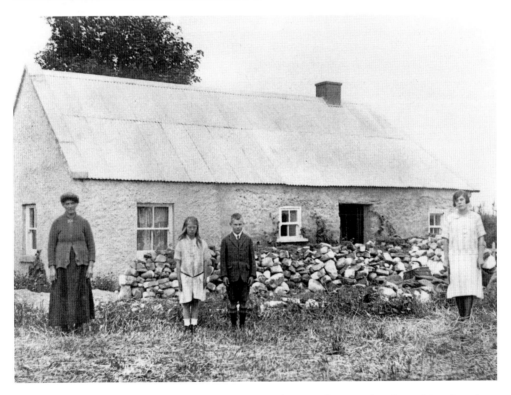

Neville's Cottage at the Maudlins, 1915. The photograph was taken by visiting American relations. A new parlour had been built for the arrival of the relations. This cottage was a mud/straw cottage. From left to right: Mary Neville, her daughter Jane (Quinn), Michael Neville and Ann Neville.

Thomas (Tommy) Murray. Murray was born in Trim in 1931, the son of Sergeant Major Tommy Murray and his wife Molly (*née* Kelly). The Murrays were originally from Rathnally. Tommy attended school in what was then the Model School run by the Christian Brothers, now the Boyne Community School. Tommy was married to Josephine (Josie) Greville from Raharney, County Westmeath. They settled in a house on Summmerhill Road and had five children, all girls. He worked in Trimproof Factory, then in Trim Vocational School as a caretaker alongside Josie who also worked at the school. Tommy was an active local historian and wrote books on the history of Trim and Meath. In 1992, he founded the Meath Writers Circle and Meath Junior Writers Group. Tommy taught creative writing classes for children in Navan Library.

He had numerous books of poetry published and won many awards throughout Ireland. His poetry reflected the love and pride he had for Trim and he wrote a song called 'Come Back to Trim', which was put to music and recorded by Trim tenor Matt Gilsenan. His poem 'Once On Tara's Plane' was used in a UTV documentary about the ancient Hill of Tara.

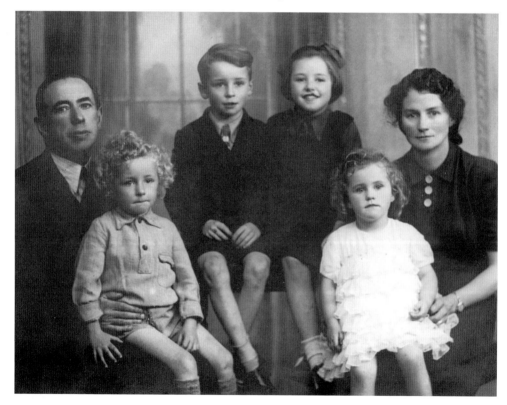

The Gilsenan family, The Mill House, 1944. From left to right: Thomas, with Joe on his knee, Matt, Marie, and Christina, with Anne on her knee.

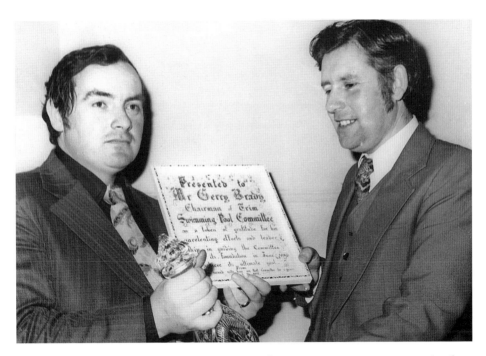

Gerry Brady (left), chairman of the Swimming Pool Committee, receives a presentation from Tom Kelly (District Court Clerk) in recognition for his work in chairing the Swimming Pool Committee. The pool, built at a cost of £80,000, was opened by Jimmy Tully TD in 1974 and served the town and its people for more than thirty years. Many people, young and old, learned to swim at the facility. Some of the staff members had worked at the pool for up to twenty years.

Local Tenor Matt Gilsenan had a chance meeting with Irving Fleming, the Music Director of the Scottsdale Symphony Orchestra, in 1976 through mutual friend Fr Eugene Maguire. Matt sang a series of Irish concerts with the aforementioned orchestra, commencing on St Patrick's Day 1977. From 1981 onwards, Matt brought his singing pal Michael Meegan with him, and together they sang their way into the hearts of the Irish communities from New York to Phoenix and from Scottsdale to La Jolla in California. Matt finished the series with a solo recital in Sun City Grand, Arizona, in March 2006. Matt's desire to sell Ireland abroad and particularly his native Trim and the Boyne Valley Region was always at the forefront of his thoughts. In 1981, Matt chose to pay tribute to the legendary Irish songwriter Jimmy Kennedy, who had strings of hits during the 1930s, 1940s and 1950s with such songs as 'Harbour Lights', 'Red Sails in the Sunset', and 'Isle of Capri'. In January 1981, he had a breakfast meeting with Kennedy in a Dublin hotel. In appreciation of the occasion, Jimmy recorded a special greeting to Matt and the members of the Scottsdale Symphony Orchestra.

Adrian Sturdy, John Farrell and John Kiely in Kiely's Yard, 1982.

Dot Heery and Jackie Kiely on Dobyns Island, Market Square, 1967. Dobyns Island was a traffic Island and named after the council engineer who designed it. When traffic increased in the town it had to be removed as it was causing congestion.

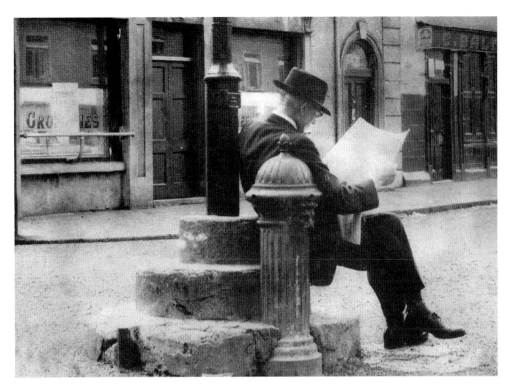

Col Balfe reads his paper sitting on the steps of the sign post on Market Square. His shop is in the background of the photograph. The water fountain provided good drinking water and there were also water fountains on Patrick Street, Watergate Street, Mill Street, High Street, and Haggard Street. They were sadly removed during upgrading of footpaths.

Celebrations in the Bridge Bar, Bridge Street, attached to the Old Bridge from which the street gets its name. From left to right: Jack Dempsey, Peter Gibney, Paddy Redmond, Frank Lynch, and Peter Dempsey.

Jack Flood at Boardsmill Stud, Trim, with his young sister Babs, 1927. Boardsmill church is built on the grounds, originally the property of the Flood family. The (original) building was used for storing corn at harvest time and was used in conjunction with the Corn Mill, still situated to the west side of the church. The corn store was cleaned out and used for Mass on Sundays during the period 1800–1850. The church was fully renovated and the middle aisle was extended, *c.* 1950, with a new gallery built over the extension in the middle aisle. Up to the renovation, there was a large pipe organ but because of its size it was removed and replaced by a smaller organ on the gallery. All the seating and windows were replaced at this time with help from the parishioners. Their generous donations are acknowledged by plaques on the seats and windows.

Austin and Marcella O'Brien outside their house in Patrick Street in the 1980s. Austin was very well known in Trim and was a memorable character. His wife Marcella was older than him and blind, although he died before her. They looked after each other very well and Austin also loved to help people; it wouldn't be unusual for him to stop traffic to help someone to cross the road. Cellie, as Marcella was known, told great stories and loved to chat. She liked to use snuff and worked in the laundry in St Joseph's Hospital for many years.

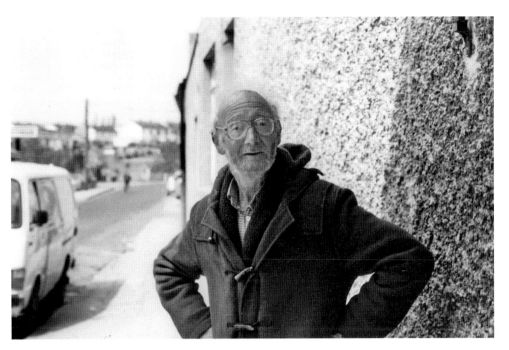

Jimmy Finnegan, 1994. Jimmy was a much-loved character from Trim. His smiling face welcomed natives and strangers alike. He could converse with anyone; the weather was always a good topic and he became known as 'The Weatherman'. In 2000, a new street was named after him, 'Finnegan's Way', which links Castle Street and Emmet Street.

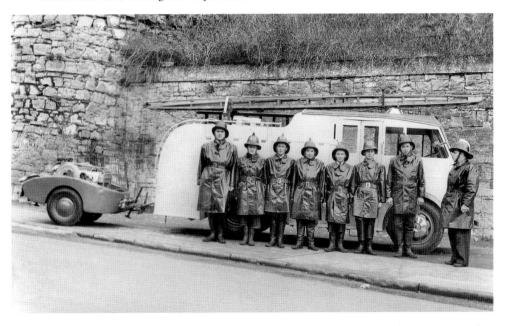

Silver Bullet Fire Engine with Trim firemen in the 1960s. From left to right: George Douglas, Johnny McEvoy, Paddy McLoughlin, Sean McNulty, Tom Markey Joe Conlon, Harold Douglas and Wally Carter.

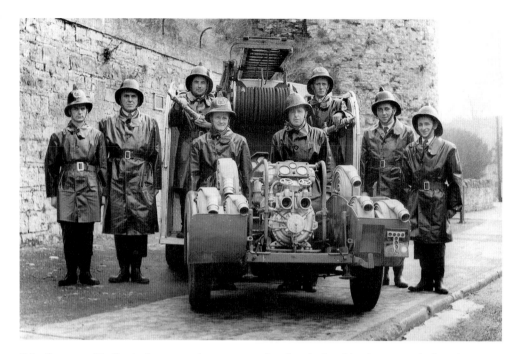

Trim firemen with the trailer pump that was towed to fires by local hackney men before they had the silver bullet engine, 1960s. From left to right, front row: Joe Conlon, George Douglas, Johnny McEvoy, Wally Carter, Harold Douglas, Tom Markey. Back row: Sean McNulty, and Paddy McLoughlin.

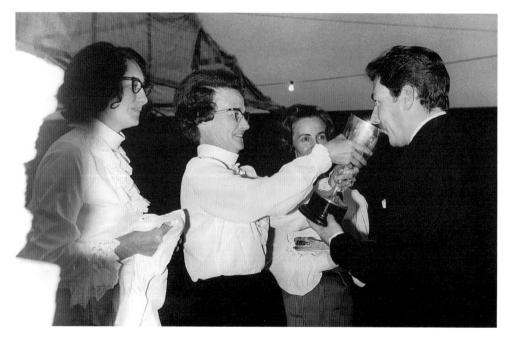

Gay Byrne receives a drink of mead from Peggy Mullen as Breda Buckley looks on at the Scurlogstown Medieval Banquet, 1969.

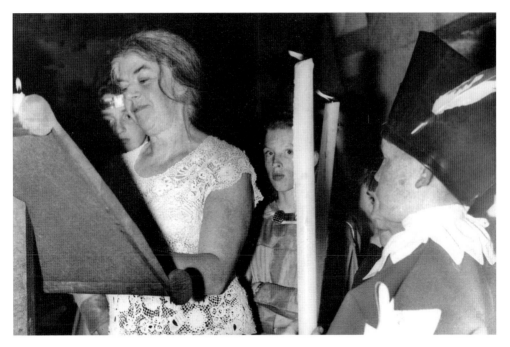

Writer Mary Lavin (10 June 1912–25 March 1996) reads from one of her books at the Medieval Banquet at Scurlogstown Olympiad, 1969. Tom Lavin, Mary's father, approached Lord Dunsany, a well-known Irish writer, on behalf of his daughter and asked him to read some of Mary's unpublished work. Suitably impressed, Lord Dunsany became Mary's literary mentor. One of her most notable works is a collection of short stories entitled *Tales of Bective Bridge*.

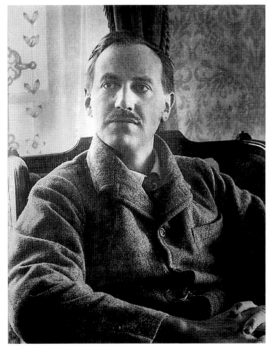

Edward John Plunkett, 18th Baron of Dunsany, was an Irish writer and dramatist. He published more than eighty books under the name of Lord Dunsany, mainly in the fantasy genre, and hundreds of short stories, plays, novels and essays. He lived much of his life in Dunsany Castle, County Meath. He was involved in the Irish Literary Revival, donating to the Abbey Theatre and associating with such literary greats as W.B. Yeats, Lady Gregory, AE Russell and Padraic Colum. Dunsany's contribution to the Irish literary heritage was recognised through an honorary degree from Trinity College, Dublin. The Dunsanys held the castle and surrounds until 1993 when, after years of discussion, Lord Dunsany sold the land and buildings to the State.

Sir William Rowan Hamilton was a physicist, mathematician and astronomer who as a child lived with his uncle, James Hamilton, who ran Talbots Castle School in Trim. He later studied at Trinity College Dublin and in 1827 was appointed Professor of Astronomy there and Astronomer Royal of Ireland. His contributions to mechanics, algebra and optics led to his knighthood in 1835 and his election as President of the Royal Irish Academy in 1837. He died in 1865.

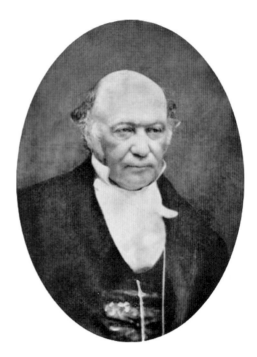

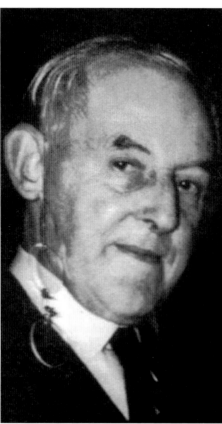

Frank Duff, founder of the Legion of Mary, was born on 7 June 1889. His grandfather, Michael Francis Freehill, was appointed headmaster of the Model School in Trim when it opened in 1849. He was educated at Blackrock College, entered the civil service at 18 and had a brilliant career in the Department of Finance. He became Private Secretary to Michael Collins and on 22 August 1922 waved goodbye to Collins as he set out for Cork. They never met again because Collins was shot that very day. Frank joined the St Vincent DePaul in 1913. At the age of 27 he published his first pamphlet entitled 'Can We Be Saints?'. In the pamphlet, he expressed the conviction that all, without exception, are called to be saints. He was invited by Pope Paul VI to attend the Second Vatican Council as a lay-observer. His work has been praised by five Popes and by innumerable cardinals and bishops and his cause for Beatification was introduced by Cardinal Connell in June 1996.

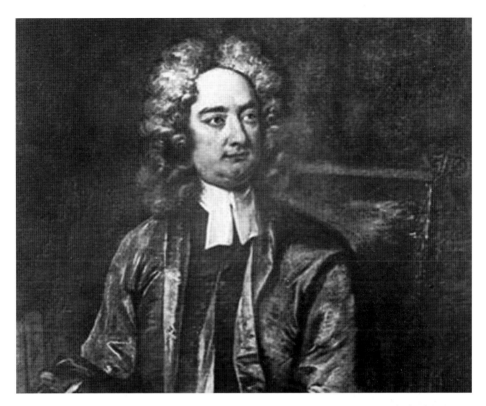

Johnathan Swift was dean of St Patrick's Cathedral, Dublin from 1713 until his death in 1745. Prior to going to Dublin he served as dean of Laracor, Trim from 1700 to 1712. During the time that he ministered to a very small congregation at Laracor. His friend Esther Johnson (Stella) and her companion Mrs Dingley came to live in a modest thatched cottage close to the church at Laracor. The remains of Stella's Cottage is still there today.

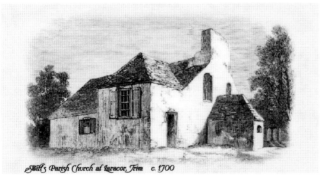

Swift's Parish Church at Laracor, Trim c. 1700

Stella died in Dublin on Sunday, 28 January 1728, and is buried in St Patrick's Cathedral, Dublin. On the night of her death Swift wrote in his diary: 'the truest, most virtuous and most valuable friend that I, or any other person, was ever blessed with. I never heard her make a wrong judgment about anyone or anything ... She loved Ireland better than the generality of those who owe their birth and their riches to it.'

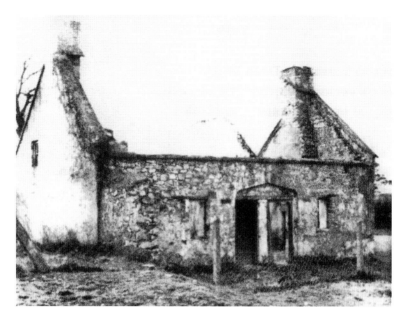

The ruined Stella's Cottage, *c.* 1964.

The two front doors of Stella's Cottage. The semi-detached houses had a thatched roof and the windows had diamond-shaped glass.

6

COMMUNITY

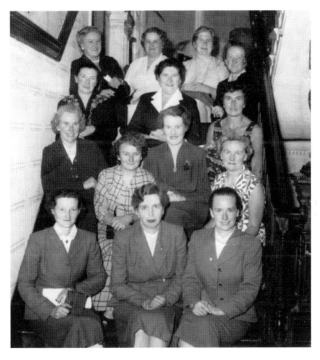

Irish Country-Women's Association members on a trip to Dublin in the 1950s. From left to right, back row: Mary Brown, Muriel Rountree, Mrs McGough, Mary Carton. Third row: Mrs Flaherty, Kathleen Mekiterian, Cecilia Brody. Second row: Mary O'Shea, Christina Gilsenan, Dr Eileen O'Reilly, Patty Tyrell, Front row: Mrs Brady, Mrs Ryan, Mary Moore (poultry instructress). The ICA branch in Trim at this time were very active and had many demonstrations and outings. However, sadly it no longer exists in the town.

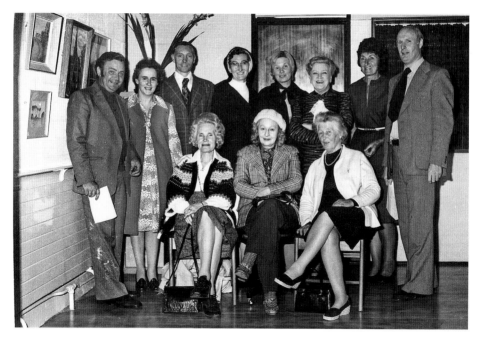

Artists at their art exhibition, 1973. From left to right, standing: Ray Crinion, Anne Crinion, Pat Sherlock, Sr Asumpta, Catherine Potterton, Mary Brown, Cecilia Brody, Martin Craige. Seated: Kathleen Lynch, Babs Clarke, and Dr Murnane. The exhibition was held in the newly built Castle Restaurant Ballroom.

Shop Window Competition, 1992, as part of the Scurlogstown Olympiad. From left to right: Michael O'Connor (Committee), Maureen Conlon (representing John Spicer & Co. Ltd) receives the prize from Michael A. Regan (Sponsor) and Maurice Harlen.

The Trim Vintage and Veteran Car Committee made a presentation in 1996 to Mrs Muriel Roundtree, owner of the Porchfields, where the Committee's Annual Car Rally is held each year. From left to right: Iris Wilson, George Douglas, Michael McCormack and Muriel Roundtree (seated). Muriel and her brother David Sharpe were owners of the lands and ran a dairy in the 1950s from their premises which is now known as Blackhall House, High Street. The Porchfields were obtained by the Council and it is a great amenity for the town as a people's park. The Trim Vintage and Veteran Car Committee has been running since 1985 and contributes a great deal to local charities.

Michael McCormack, of the Trim Vintage and Veteran Car Committee, presents a cheque for €6,000 to Christum Leonard for Meath Hospice Home Care, 1996.

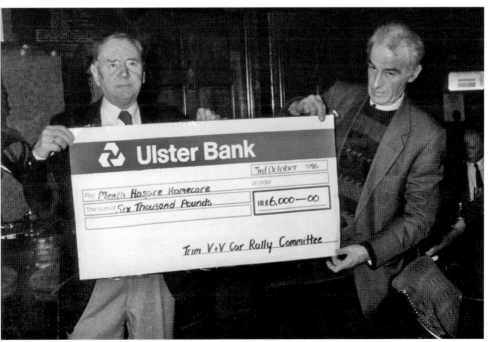

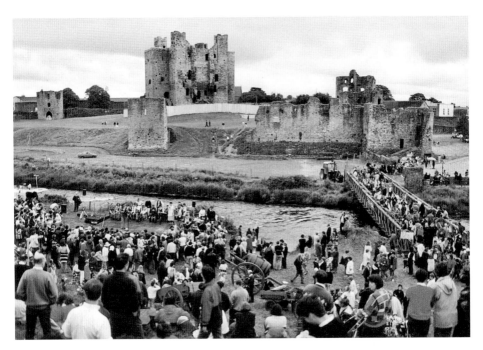

Crowds making their way to the Haymaking Festival, 1993. The Scurlogstown Olympiad had been renamed 'The Haymaking Festival' in that year. In this photograph, the army had erected a Bailey Bridge over the Boyne to link up Frenches Lane and the Porchfields. A permanent bridge was erected there in 2000 and aptly named the Millennium Bridge.

Judges for the Entente Florale competition pictured at St Mary's Abbey in 1993 with members of the committee and local councillors. Back row includes Revd Michael Walsh, Elizabeth Rourke, and Ray Crinion. Front row includes Phyllis McCormack, Sheila Dunne, Mary Menton, Anthony Conlon, Noel Dempsey TD, Bernadette McCormack, Mons Sean Kenny, Robert Griffith Chairman UDC, Kieran Cummins, and Tom Dempsey.

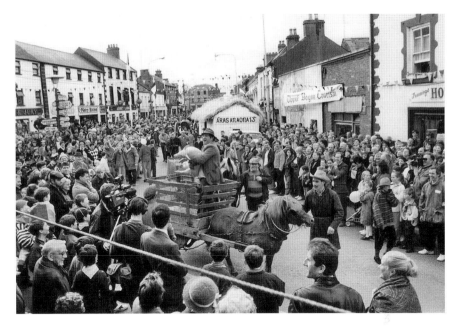

St Patrick's Day Parade, 1990. The parade in Trim was revived by the late Ray Crinion in 1987. He formed a committee, of which he was chairman, and ran a very successful parade which grew in strength and numbers each year, continuing to be a popular event to this day.

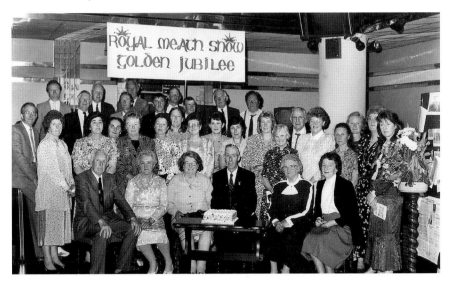

Royal Meath Show Golden Jubilee, 1990. Among those photographed are: Gerry Baker, Tommy Darby, Noel Hayes, John Bird, Hugh Leonard, Tom Gillespey, Vitch McComb, Louie McLoughlin, Eugene O'Reilly, Pat Donnegan, Arthur O'Connor, John Bligh, Caroline McComb, Nora Egan, Mary O' Rourke, Anne Canty, Rita Eivers. Middle row: Patricia Traynor, Millie Keegan, Anne McEntaggart, Betty Daly, Monica Wolfson, Helen Murtagh, Celene Kearney, Iris Wilson, Moya Kane. Front row: Vincent Eivers, May Mcgrath, Mrs Mitchell, John Joe Griffin, Muriel Rountree, Mrs McEntaggart.

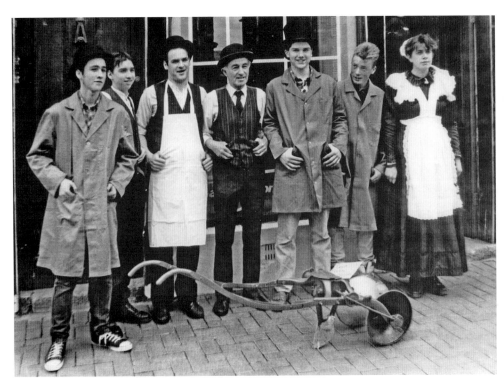

The staff of Leonard's, Market Street, dressed in an old style for the Fair Day, 1992. From left to right: Eamon Byrne, Christopher Leonard, Stephen Leonard, Christum Leonard, Tony Anderson, Garry Rigney and Bernadette Douglas.

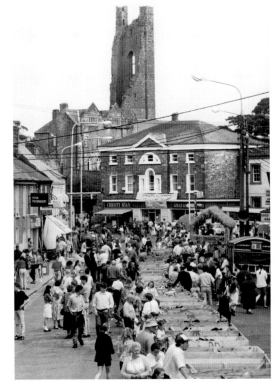

A scene from the Scurlogstown Olympiad on Market Street, 1992. It was an 'Auld Fair' on the streets of Trim featuring the selling of lambs, sheep, goats, pigs, fowl, horses, ponies and other livestock. There were displays and demonstrations by cobblers, blacksmiths, tin-smiths, coopers, wheelwright, sheep-shearers, people carding and spinning wool, as well as various arts and crafts, higglers (dealers), Cheap John (a stall that sold everything from a needle to an anchor), the Medicine Man and street singers.

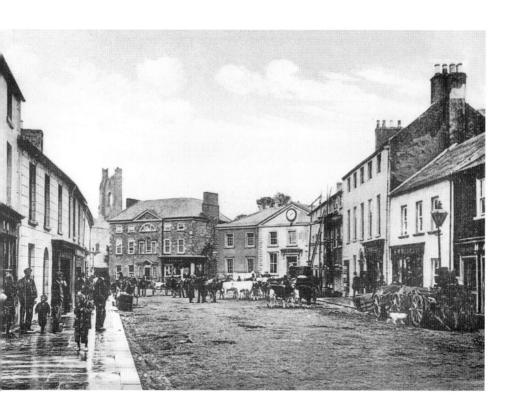

Market Day in Trim, *c.* 1945.

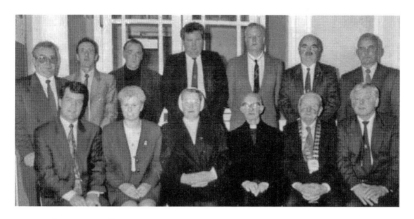

Trim Urban Councillors, 1994. From left to right, back row: Ray Crinion, Larry Murray, Chris Cleary, Vincent McHugh, Des Clancy, Phil Cantwell, and Michael Lenihan. Front row: Noel Dempsey, Jackie Maguire, Sr Carmel Mulligan (Matron of St Joseph's), Mons Sean Kenny, Tom Dempsey, and Robbie Griffith.

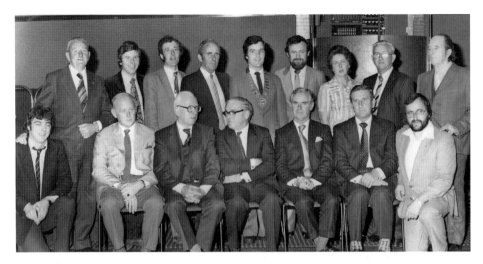

The first sitting of the High Court at Trim, 1982. The Trim Court houses High Court, Circuit Court, and District Court sittings. From left to right, back row: Tom Dempsey, Frank Anderson, Larry Murray, John Keirns, Noel Dempsey, Brian Kelly, Babs Allen, Christopher Andrews, Frank Reilly (legal advisor). Front row: John O'Neill (town clerk), Michael McFadden (assistant county manager), Mr Justice Thomas Finlay, Mr Justice J. McMahon, and Mr Justice Rory O'Hanlon, Frank O'Brien (county manager), Liam Carter.

According to the Local Government (Ireland) Act, 1898: '[The] First Meeting of the Councillors of the Borough Urban District of Trim was held on Monday 23rd. January 1899. And continued without a break until May 2014 when Urban Councils were abolished and replaced by a Municipal District Council. There are 40 Councillors and East Meath has 6 councillors representing our area.'

Trim Urban District Council Meeting, 1975. From left to right, back row: Frank Anderson, John O'Neill (town clerk), Christy Andrews, Brian Kelly, John Keirns, Paddy Hand, Liam Carter, Michael Cullen, Larry Anderson. Front row: Michael McFadden, Frank O'Brien (county manager), Tom Dempsey, Paddy Smith (Bank of Ireland), Mervyn Morrison (Bank of Ireland).

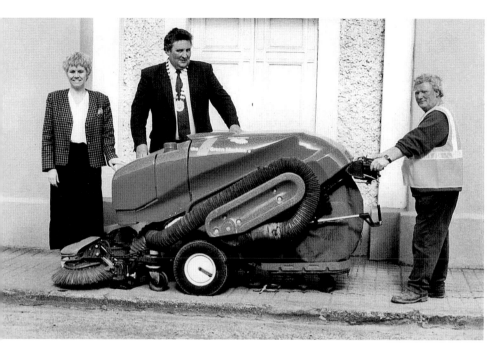

Mattie Finnegan with his new 'Green Machine', 1996. Jackie Maguire (town clerk), Vincent McHugh (chairman of Trim UDC), with Mattie Finnegan while he shows off his new cleaning machine.

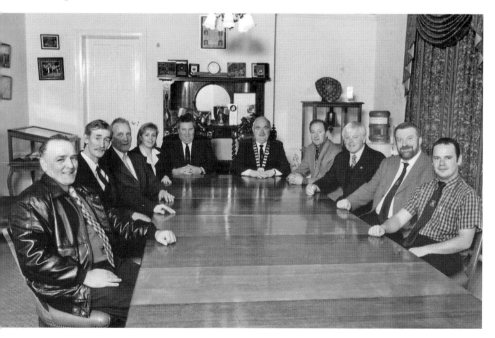

Trim Urban District Council Meeting, 1997. From left to right: Chris Clery, Jimmy Peppard, Michael Lenihan, Mary Maguire (town clerk) Vincent McHugh, Phil Cantwell (chairman), Gerry Reilly, Robbie Griffith, Danny O'Brien, and Peter Crinion.

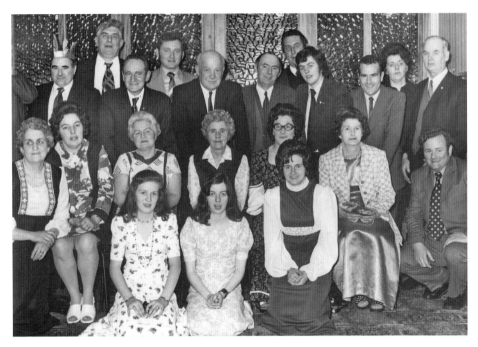

Fireman's Ball, 1972. From left to right back row: Sean McNulty, George Douglas, Tom Markey, M. Flanagan, Bob Flanagan, Robert Bradly, George Douglas, Anthony Conlon, Patrick Colgan, Janette Douglas, Joe Conlon. Middle row: Maureen Conlon, Babs Bradly, Nell Markey, Margaret Flanagan, Molly Douglas, Vera McNulty, Johnny McEvoy. Front row: Mary Conlon, Lily Hughes, Bridget Colgan.

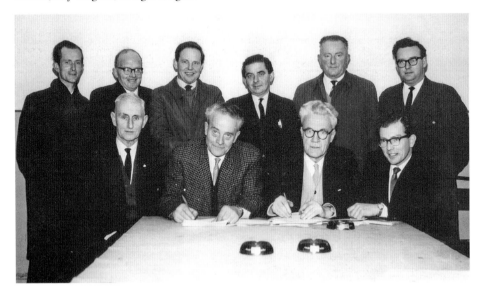

St Loman's Credit Union in 1963, the year after it was founded. From left to right, back row: Hugh Hannon, Jack Kelly, Gerry Lee, Tom Brogan, Barney Ferran, Matt Gilsenan. Front row: Michael Spellman, C.J. Tyrell, John McManus, John Keirns. St Loman's Credit Union ran successfully until 2015 when it merged with Drogheda Credit Union Ltd.

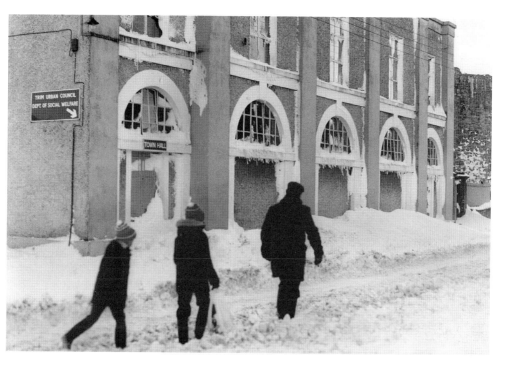

The Town Hall in 1982. During heavy snow P.V. Dunne, with his sons Paul and Fergal, make their way to Sunday Mass. Trim Town Hall has a long association with local performing arts. Long before the Musical Society was born Trim boasted an active Drama Society. Local legend would suggest that it started life as a Market House in 1853. The hall also doubled as a 'film house' before the Royal Cinema opened in the early 1950s.

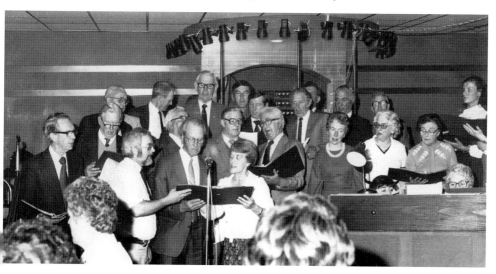

Musical Society Reunion, 1978. Gathered around the microphone are Matt Gilsenan, Willie Loughran, Rosalie Giles, Barney Harte, J.J. Fallon, John Goggins, John Donoghue, Chrissy Healy, Mary Wheeler, Olive Rice, Ollie O'Reilly, P.V. Dunne, Ted Murtagh, John Kelly, with Kathleen Harte at the piano.

From left to right: -?-, Kathleen Harte, Barney Harte, Margaret Gaughran, and Christina Gilsenan at the 1978 Musical Society Reunion.

The Town Hall post its glory days.

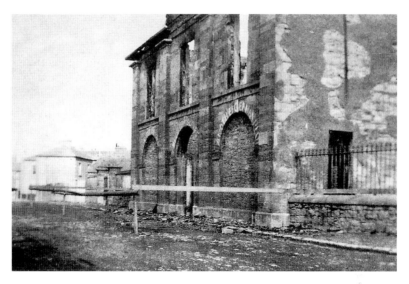

The burned-out Market House (Town Hall), 1922 as a result of a retaliation by the Black and Tans for the IRA raid on Trim RIC Barracks.

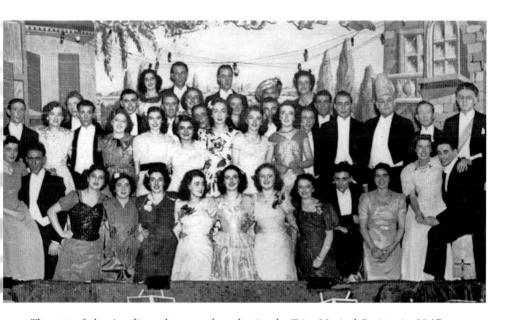

The cast of the *Arcadians*, the second production by Trim Musical Society, in 1947.

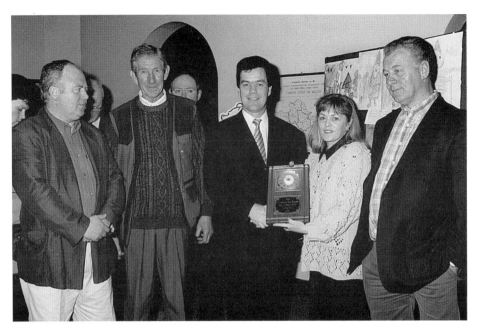

The presentation of 'The best float award' in the 1996 St Patrick's Day Parade. From left to right: Anthony Conlon, Michael Harte, Noel Dempsey TD, Mary Maguire (Town Clerk) and Val Collins.

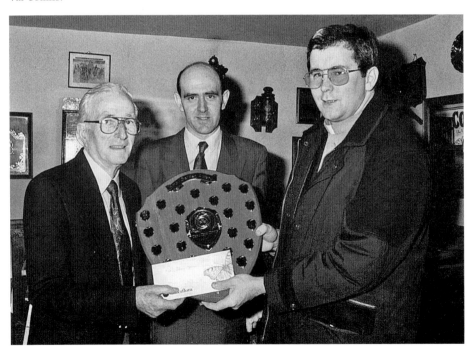

Billy Giles receives a Tidy Town Award from Fr Martin Halpin, CC, in 1996. Cieran Cummins is in the centre of the photograph. Trim has a successful history with the Tidy Town competition, being the overall winner in 1972, 1974, and 1984.

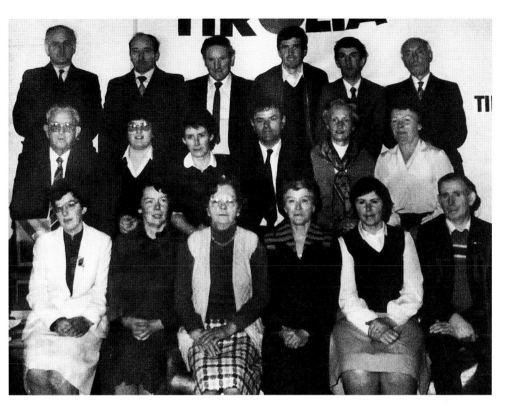

Trim Pitch and Putt Club official opening at the Castle Grounds, 1983. From left to right, back row: Peter Canning, Tom Gibbons, Eddie Byrne, Bernie Lacey, Patsy Farrell, Peter Darby. Middle row: Christopher Andrews, Bernadette Kelly, Angela Owens, Frank Dignam, Eilish Nannery, Betty Daly. Front row: Gertrude Farrell, Helen Cunningham, Sue Fox, Rosalie McCormack, Nellie Hannon, Ferdie Gibney.

Trim Pitch and Putt Club was formed around 1951, in Redpath's Farm at Drinadaly on the Ballivor Road. The founding members included Christy Bird, Mick Lynam and the only surviving member today, Mixie McLoughlin. The club was registered with the Pitch and Putt Union of Ireland in 1954, making it the longest registered club in County Meath. The club remained at Redpaths for twenty-two years until the lease ceased upon the death of Alec Redpath. For the next two years, the club was sited at The Mill in Scurlogstown before moving to the field behind Jack Quinn's pub for a further five years. Around 1981, with the permission of Lord Dunsany, the club found a new home in the grounds of Trim Castle, becoming firmly established there with its official opening in 1983. Following the transfer of ownership of the castle in 1994 to the OPW, the club moved to Harnan's Field for the next five years. Finally, they bought the land from the council in the townland of Canty's Bottoms for their present course, which sits comfortably on Johnathan Swift Road in the shadow of the OPW. Trim Pitch and Putt Club are one of the few clubs in the country to own their own course.

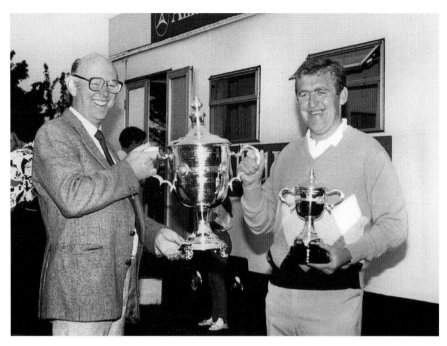

John McInerney with Paul Rayfus in 1987, after Paul (right) had won the West of Ireland Golf Championship.

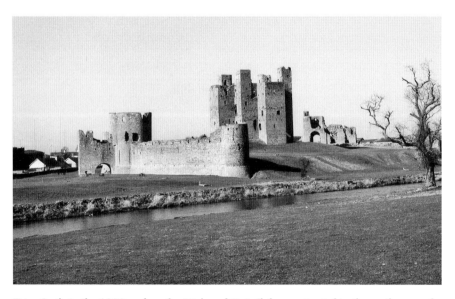

Trim Castle in the 1980s, when the Pitch and Putt Club was situated in the castle grounds.

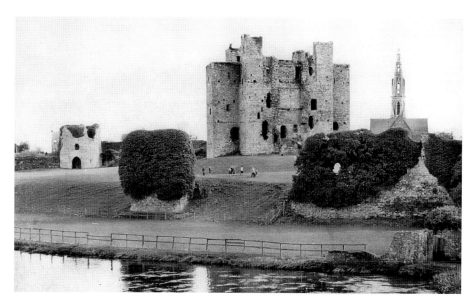

An international student task force attacked Trim Castle in 1966. It included students from the north of France, from which the original builders of the castle came. The students took on the gargantuan task of stripping the walls of ivy and then spraying the roots left on the walls. The French were joined by students from Holland, Sweden, Spain and Ireland. The leader of the group was Mr Simon Hewatt. The students were accommodated in local schools and in the Meath Diocesan Hall. The people of Trim extended every co-operation and help to the students. Peggy Fay loaned them a cooker with pots and pans. Food was donated too. GAA matches and other entertainments were laid on for the students. They started work at 8 a.m. and were in Trim for three weeks. The only cash payment the group received was a £200 grant from Bord Failte towards provisions.

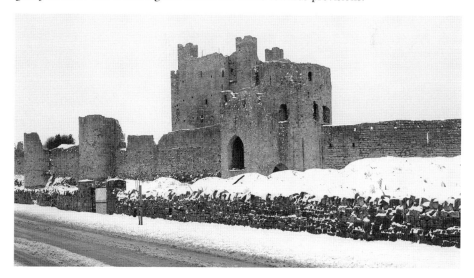

Snow at Trim Castle, 1990. The wall and gate along the road at the front of the castle were removed in 1996. The grounds are now opened up, giving a great view of the castle, the tower and barbican.

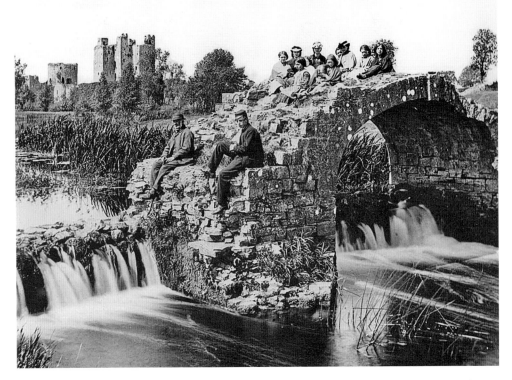

The Draw Bridge, with the weir flowing under it, *c.* 1900. The weirs were eventually removed in 1970, during the Boyne drainage, to combat flooding.

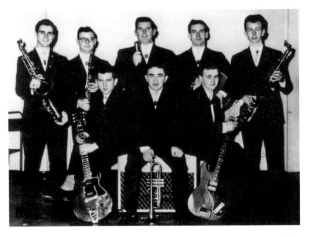

The Hunters Show Band, 1960s. From left to right, back row: Albert Maher, Michael Smith, Henry Douglas, Paddy Tully, Tony Clarke. Front row: Jimmy Murray, Jody Farrell, John Owens. The Hunters were known as Ireland's youngest show band. Show bands started in the 1950s and gained wide popularity in the 1960s, filling dance halls all over the country.

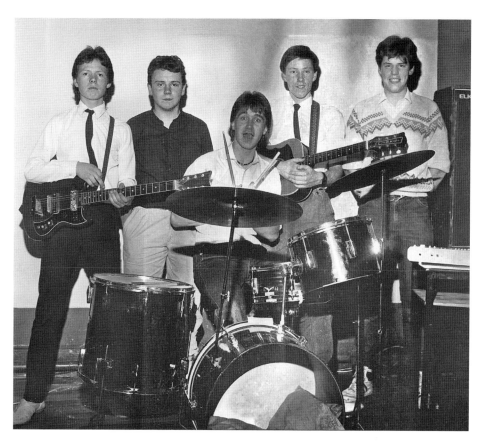

Child's Play Band, 1985. A local band formed by five school friends. From left to right: Ken Gillick, William Crinion, Peter (Cosy) McConville Alan Doran, Baron McDonnell.

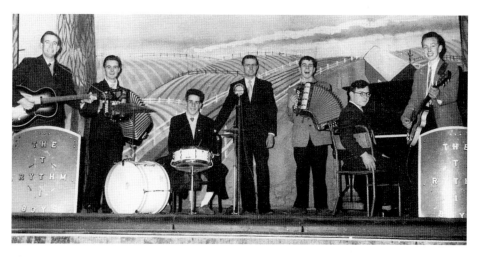

The Rhythm Boys, 1958. From left to right: Michael Bird, John Owens, Sean Dowd, Anthony Owens, Albert Maher, Michael Smith, Tony Clarke. The Rhythm Boys were a forerunner of The Hunters Showband, as many of the band's members graduated to the latter group.

Rogues Gallery Ballad Group, 1980s. From left to right: Frank Connell, Michael Rispin, Seamus McGarry, and Johnny Murray. Johnny Murray was an established bagpipes player and featured in the film *Braveheart*, playing the bagpipes.

Rumble Fish Band, 1996. From left to right: Niall Diskin, Gemma Lacey, Stephen Doyle, Gerrard Carty (with drum sticks).

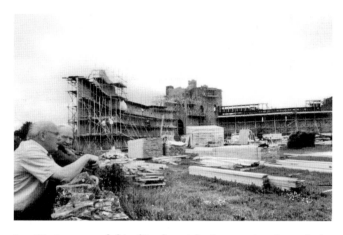

Joe Fitzsimons and his friend watch the construction of the *Braveheart* film set at Trim Castle, 1994. *Braveheart*, telling the story of William Wallace and the First War of Scottish Independence (1296–1328), was directed by and starred Mel Gibson. Trim Castle, a massive ruin, was brought to life with extensive wooden buttresses and a gate that alone weighed 7 tons and was used as the fortified English town of York. A 'London Square' was also created at Trim, on the other side of the castle wall. (Trim Castle can also be seen in Sam Fuller's 1980 war movie, *The Big Red One*, starring Lee Marvin and Mark Hamill.)

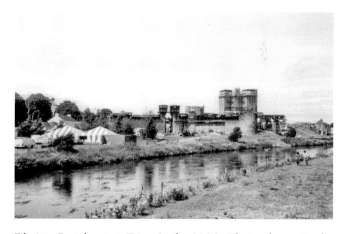

Filming *Braveheart* at Trim Castle, 1994. Filming began in the August of 1994, with hundreds visiting Trim every day to watch the filming from whatever vantage point they could find. This was a great boost to tourism in the town. The $50 million film went on to win five Academy Awards.

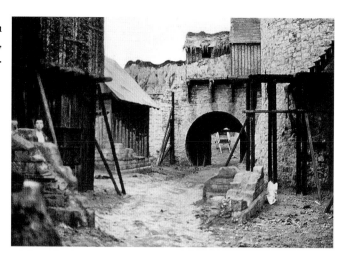

The town of York within the Trim Castle grounds, made for the film.

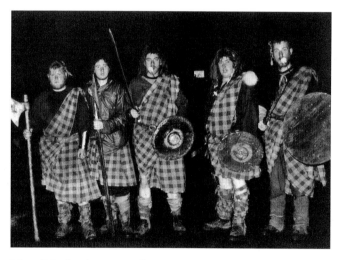

Many Trim locals were used as extras in the film. The battle scenes in this movie were heralded at the time as the greatest in decades and set a trend for war films from then on. For the Irish film industry, *Braveheart* brought a new lease of life and highlighted how attractive the country could be as a location. Then Minister for Arts, Culture and the Gaeltacht, and current President, Michael D. Higgins was instrumental in the deal made with the production company to film here. In exchange for allowing them to use Irish landmarks, like Trim Castle, the company had to agree to take on Irish people as part of the crew. This meant that many of the assistant directors, cameramen and producers were Irish and the experience they gained throughout the process helped not just their own careers but the development of the film industry here as a whole. Thanks to the FCA being a huge part of the battle scenes in *Braveheart*, Ireland was chosen for films such as *Michael Collins* the following year and the year after that for *Saving Private Ryan*.

7

BUSINESSES OF TRIM

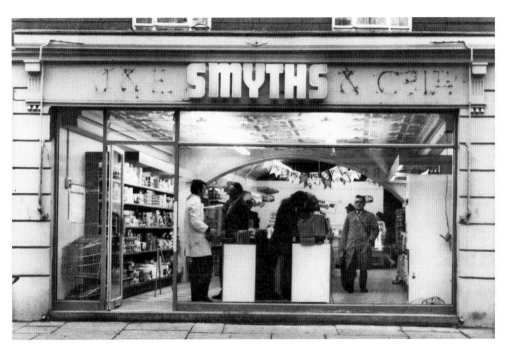

J. & E. Smyth's new shop front in 1970, showing the open supermarket plan. Christopher Andrews is on the right-hand side of the photograph in the window. The old sign was still visible behind the new plastic one. The wholesale firm of J. & E. Smyth's & Co. Ltd, founded by brothers Edward and John Smyth in 1890, were a small bottling business of stout and beer. In 1906, the Abbey Mineral Works was established, followed by a bread and confectionery business. They were also whisky bonders, undertakers, fuel yard, and retail and wholesale grocery providers. By the 1950s they employed over sixty people and distributed goods to over seven counties. Their lorries and vans were a common sight. In 1970, to meet the changing times, the grocery shop became a supermarket. The company was sold in 1980 and it closed its doors in 1993. The funeral home and undertaking business was purchased by Johnny McEvoy and is still successfully run by his daughter Lisa and her husband Declan Rispin.

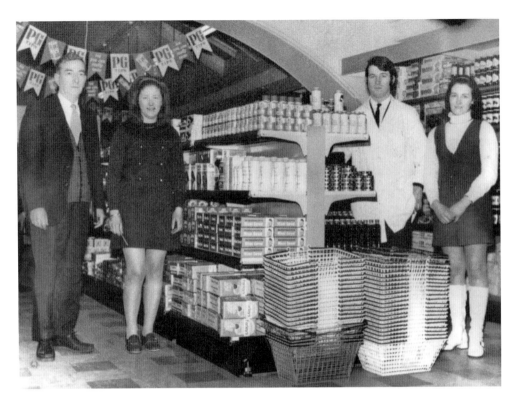

Billy Giles, Mary McEvoy, Danny
Fay and Nora Clavin, staff in
Smyth's new supermarket.

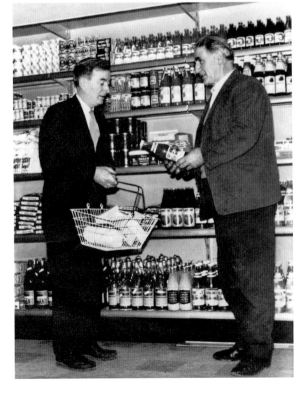

Billy Giles shows customer John
Bligh how the new supermarket
system works. Before supermarkets,
customers were served at the
counter where the staff would fetch
and wrap the customer's items.
A handwritten duplicate-docket
was then given to the customer as
a receipt of the transaction. In the
photograph, John is holding a bottle
of Smyth's minerals, which was a
household necessity at the time.

Liam Anderson and Henry Douglas, sales representatives for J. & E. Smyth's, 1984.

J. & E. Smyth's office staff, 1984. Mary Rayfus, Teresa Flynn, Liam Anderson, Henry Douglas, Margaret Sherrock, Philomena Caffrey.

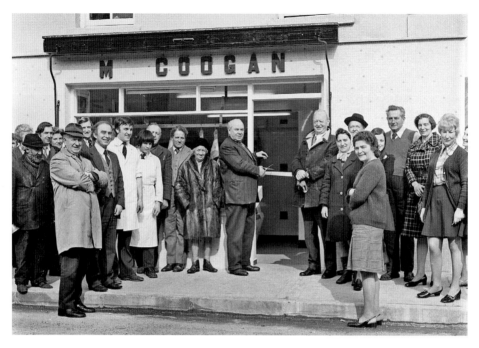

Dinny Fox, chairman of the High Street Traders, cuts the tape officially opening Michael Coogan's new butcher's shop in High Street, 1972. The photograph includes: Ann Anderson, Lorraine Anderson, Mrs Byrne, Christopher Kelly (town crier), Eddie Murray, Michael A. Regan, Michael Coogan, Peter Coffey, Wally Carter, Norman Pratt, Bridget Duignan, Dinny Fox, T.J. Mekitarian, Mons McKeever, Betty Kelly, Miriam Mahony, Maurice Power, Michael Lenihan.

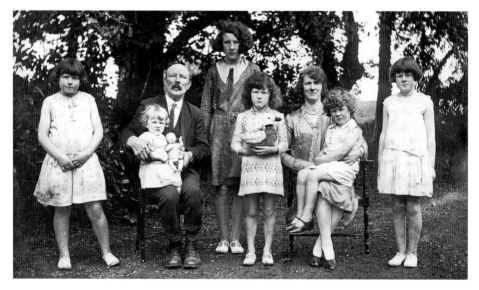

The Meehan family, Shanloth House, Trim, 1931. From left to right: Jo (Duignan), Pauline (Reilly), Peter Meehan, Betty (Brogan), Olive (Weldon), Julia Meehan, Carmel Meehan, Gertie (Ryan). The Meehan family had a pub and butcher's on Emmet Street. Pauline Reilly is the only surviving member of those pictured and resides in Emmet Street.

The Kiely family, 1936. Dan Joe and Elizabeth Kiely, publican, Emmet Street, with their six children Tom, May, Margaret, Lil, Dan Joe and Eugene. The Kiely family descendants still run many successful businesses in the town.

Christopher Leonard (Snr) came to Trim in 1929 and this is where they started the family business. This photograph was taken in the 1960s.

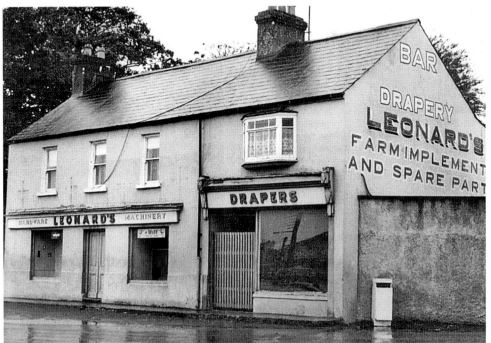

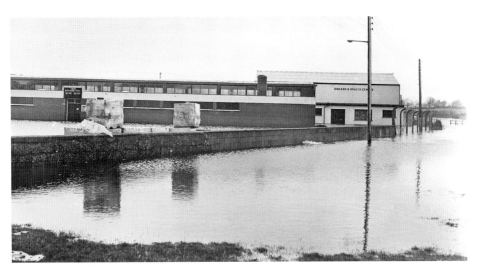

The squash courts and swimming pool under flood waters, 1982.

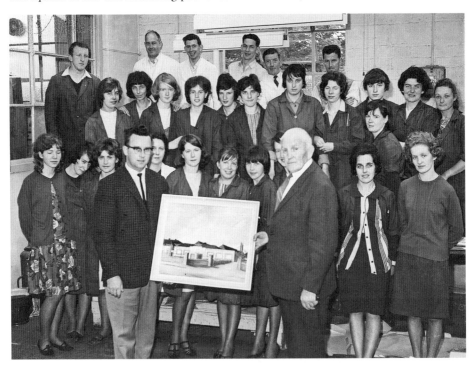

Presentation to Mr Ridgeway, 1966. Matt Gilsenan, manager of Spicer's of Ireland Ltd (Envelope Factory), presenting a painting to Mr C.J. Ridgeway, chairman of the board of directors, to mark his retirement. From left to right, back row: Paddy Doran, Sonny Buckley, Ferdie Gibney, John Brady, Eamonn Brennan, and Bill McDonnell. Middle row: Mossie Ward, Mary Rose Cox, Teresa Nolan, Frances Doran, Angela Maguire, Margaret Kelly, Kathleen Grogan, Peggy Losty, Mary Neville, Maureen McCann, and Nora Thompson. Front row: Sheila Losty, Teresa Doran, Mary Cox, Babs Allen, Mary Nolan, Lizzie Ward, M. Ward, Mary Farrell, Edna Murray, Rosaleen Bird, and Lena Finlay.

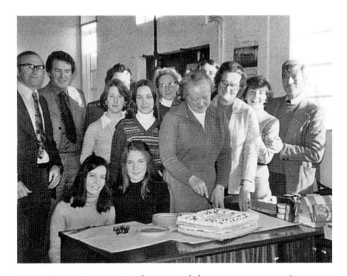

Spicer's of Trim envelope factory, 1966. In 1949, an envelope factory employing up to forty girls was set up in Trim. In 1953, a large extension was built and the factory, whose annual output ran into millions of top-grade envelopes, continued for many years. On its demise, a new envelope factory emerged, lead by members of the existing staff, and Trimfold Envelope Factory was born.

Mary Carton cutting a cake to mark her retirement as Company Secretary of Torc Factory, 1975. From left to right, back row: Brendan Davis, Dave Brennan, Teresa Dowd, Ann Clarke, Una Ennis, Mary Carton, Carmel Daly, Lily Hughes, Larry Tobin. Front row: Caroline O'Dwyer, Pauline Gunning. The factory, situated beside the Wellington monument, closed in 1984.

Wellington Monument, 1950s.

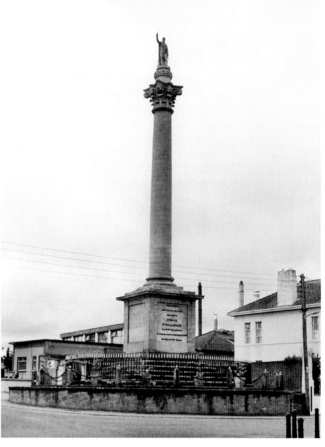

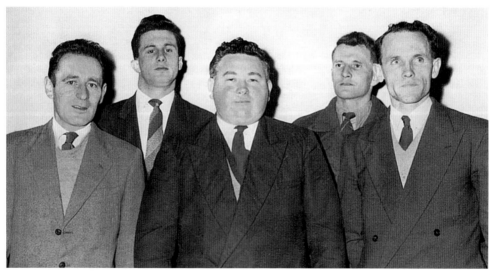

Spicer's Bakery Question Time Team, 1957. From left to right: Tom Markey, Michael O'Donnell of Loman Street, Michael O'Donnell of Clonbun, Bobby O'Brien, John Corrigan.

8

THE CHANGING FACE OF TRIM

Carrollstown House in all its glory. Carrollstown House was a large stately home on the outskirts of Trim. Built in 1883 for P.J. Dunne, it was beautifully laid out with encaustic tiles, Corinthian capitals, pilasters and architraves. All the carpenter work of the interior was of selected pitch pine and the plastering was finished in a grey coating and the ceilings with chaste cornices. At the time of this photograph, *c.* 1890, it was the residence of P.J.'s son Patrick Dunne-Cullinan, a well-known Meath sportsman, and his wife. Paddy was a familiar face around Trim and the surrounding areas. He had many interesting angles on life and in addition to riding many winners at National Hunt races he was also a keen skier and a member of the Irish four-man bobsled team. A friend once asked him to attend an audition for a film that was to be made in Ireland called *Irish Destiny*, and whilst obliging, was actually asked to star in the film because of his riding skills. The house was destroyed by a mysterious fire in 1938 while Mr Dunne-Cullinan and his wife were away. Despite all possible efforts made to quell the flames, the fire enveloped the whole structure. Another house was constructed from the stables on the site, where Mr Dunne-Cullinan and his wife lived after the fire, before selling to the B&I Shipping Company. The house has to this day been referred to locally as the 'B&I'.

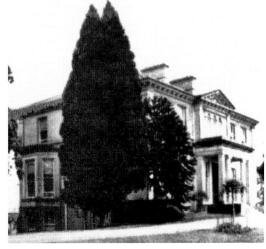

Carrollstown House
after fire damage.

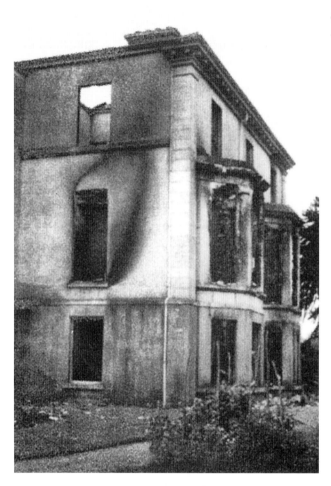

Julia Caffrey-Leonard,
from Newhaggard, Trim,
with her children. Julia's
husband Christopher
worked as a herdsman
for Mr Dunne-Cullinan
of Carrollstown House.
Julia sadly ended her
days in St Loman's
psychiatric hospital
in Mullingar, County
Westmeath, and her
children were sent to
the workhouse in Trim.

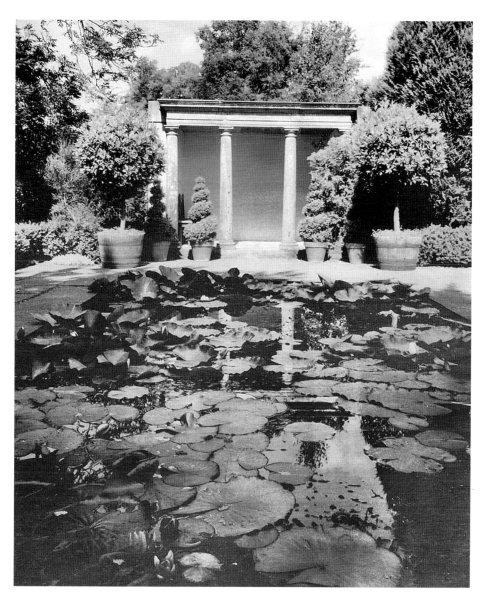

Butterstream Gardens, *c.* 1990. In 1970, the young archaeologist Jim Reynolds innocently started gardening as a pastime and he planted a rose garden at his family home farm in Butterstream. He had no great visions of Arcadia, no hint of an all-absorbing passion, no trumpets sounded in his ear, but this planting of a dozen hybrid roses was the beginning of the success which was Butterstream Gardens. He collected stones and doorways from houses that were being demolished or re-modelled in Trim. These items were used as features in different sections of his garden. Jim's garden grew with many trials and errors which he took on the chin and kept going. The twelve sections of the garden, from Tuscan temple to the Lime Tree Allees and the Canals, were a testament to his determination and vision. In 1990, Jim decided it must be time to give up the day job and try and live off his creation. This proved to be a great tourist attraction and visitors came from near and far, including Prince Charles in 1995. Sadly the same year as his father died, 2003, the gardens closed and it is now a housing estate.

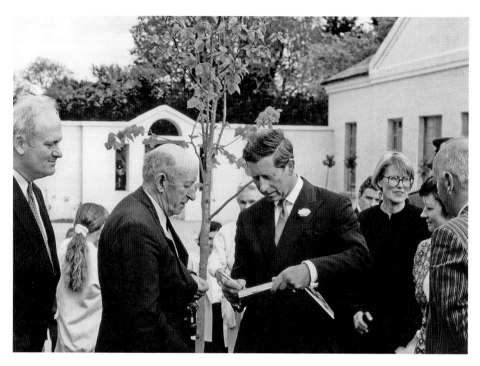

Butterstream Gardens, 1995. From left to right: John Bruton, James Reynolds Snr, Prince Charles, Darena Allen, Jim Reynolds.

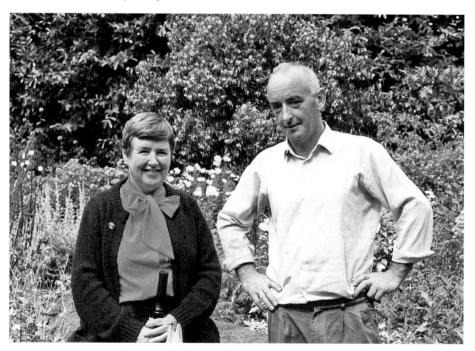

Loreto Sister Christine Gilsenan in Butterstream Garden with Jim Reynolds, 1993. Sr Christine is a Trim native and was visiting from Phoenix, Arizona, where she has lived since 1956.

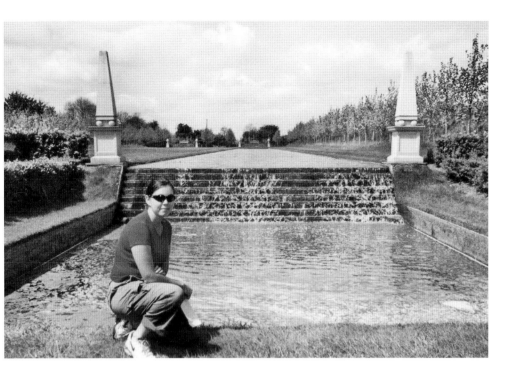

Eileen Tighe from Sydney sits at the Canal in Butterstream Gardens, 1994.

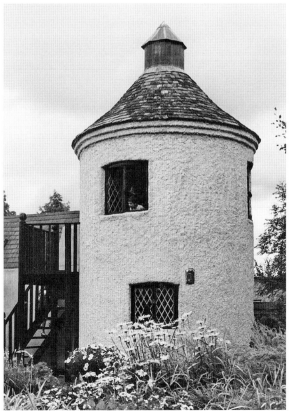

The White Garden and Tower in Butterstream Gardens.

One of the salvaged doorways
that became a feature in
Butterstream Gardens.

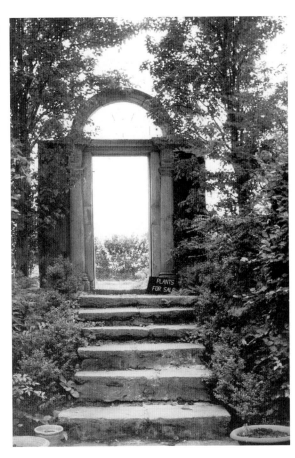

Market Street, *c.* 1900.

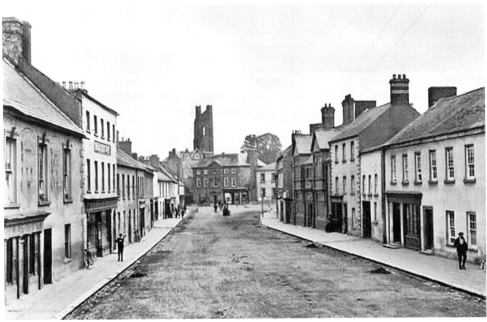

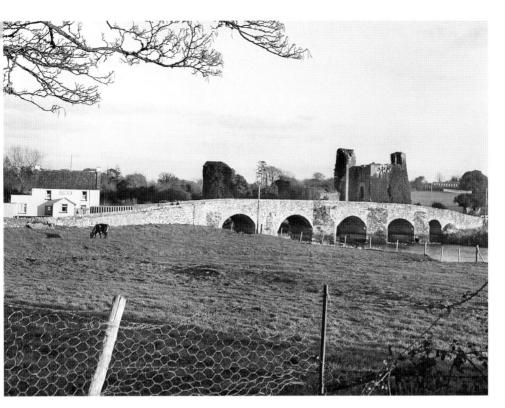

Newtown Bridge, 1965.

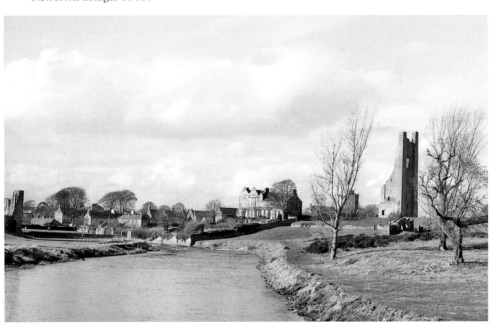

St Mary's Abbey, Yellow Steeple, and Sheep Gate, 1970. This photograph was taken after the Boyne Drainage, when the river and its banks were free from weeds.

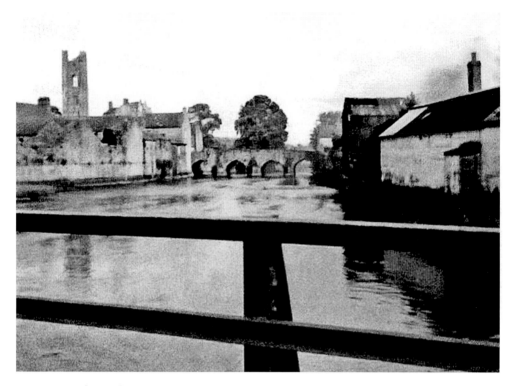

Watergate Bridge in the 1960s. On the right of the photograph is the back of J. & E. Smyth's; on the left is the back of the old gaol.

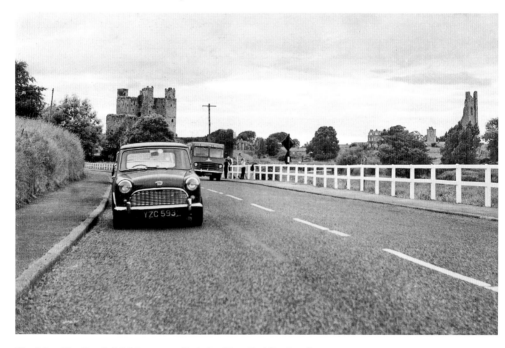

The Maudlin Road, 1964, now called the New Dublin Road.

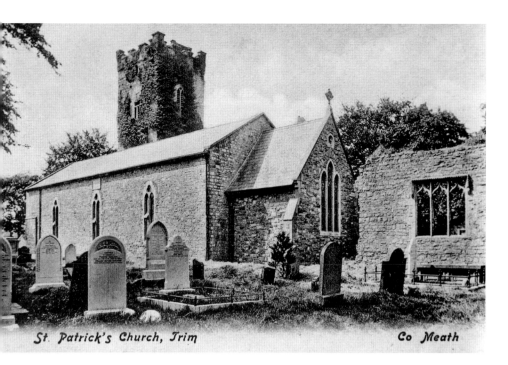

St. Patrick's Church, Trim *Co Meath*

St Patrick's church, Loman Street, *c.* 1900. The Cathedral Church of St Patrick, Trim, is a cathedral of the Church of Ireland in Trim. Previously the cathedral of the Diocese of Meath, it is now one of two cathedrals in the United Dioceses of Meath and Kildare which is part of the ecclesiastical province of Dublin. The tower is a remnant of the medieval parish church of Trim. Bishops have been enthroned here since 1536. The ruins of the original church lay behind the newer fifteenth-century church. It is reputed to be the oldest church in Ireland; however, this is disputed by a church in Armagh, which claims to be twenty years older. St Patrick's church was not raised to cathedral status until 1955. The tower clock commemorates Dean Butler, the historian of Trim. Stained glass in the west window was the first ever stained glass designed by Edward Burne-Jones (a British artist and designer closely associated with the later phase of the Pre-Raphaelite movement, who worked closely with William Morris on a wide range of decorative arts as a founding partner in Morris, Marshall, Faulkner & Co. Burne-Jones was closely involved in the rejuvenation of the tradition of stained-glass art in Britain).

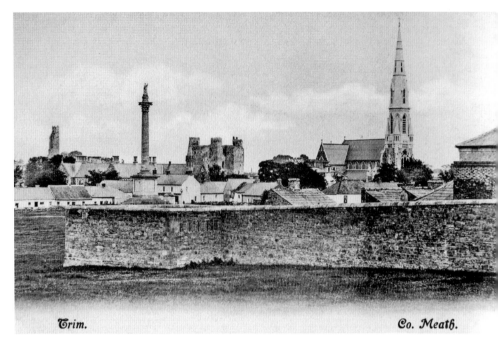

Trim. Co. Meath.

View from the Fair Green, *c.* 1903. The foreground features the wall of the old RIC barracks, which has since been developed into the Castle Arch Hotel. Three factories – Torc, Trimproof Ltd and Spicer's of Trim Ltd – were built on the Fair Green. It is still an industrial area of the town.

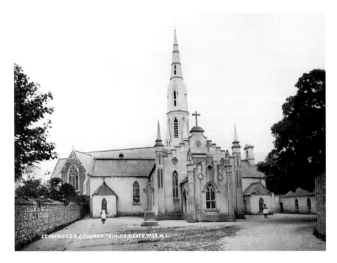

The old church in Trim that was replaced by St Patrick's church in 1903.

BIBLIOGRAPHY

BOOKS

Crinion, P. & Dignam, T., *Bygone Days: A Pictorial History of Trim* (Priority Publishing Company: Meath, 1994)

Dignam, T. & Wilson, B., *Trim Times Past* (Meath, 1999)

Farrelly, P. & Murray, T., *Around the Rock* (A. & J. Print: Meath, 2006)

French, N.E., *Scurlogstown Olympiad* (Meath, 1992)

French, N.E., *Trim Traces and Places* (A. & J. Print: Meath, 1987)

Lord Killanin & Dignam, M.V., *Shell Guide to Ireland* (Farrold & Sons Ltd: Norwich, 1962)

Lady Elizabeth Longford, *Wellington, Proud to be Irish* (Meath Heritage Office: Meath, 1992)

Murray, T., *Stella's Cottage: Johnathan Swift, Esther Johnson and Her Cottage* (Trymme Press: Meath, 1995)

Murray, T., *Where Was Wellington Born?* (Costello Print: Meath, 1992)

Potterton, M. & Seaver, M., *Uncovering Medieval Trim, Archaeological Excavations in and Around Trim, Co. Meath* (Four Courts Press: Dublin, 2009)

OTHER SOURCES

Farrell, Revd A., *The History of St Patrick's Church*, Broadcast Lecture, Trim, 2002

www.meath.ie/tourism/heritage/heritagetowns/trimheritagetown/

www.trimtown.ie

www.britainfromabove.org.uk

The Boyne (pamphlet) *5,000 Years of History: A Guide to the Royal County of Meath*

The Irish Builder magazine 1883, June 2015 edition

Also from The History Press

Irish
Revolutionaries